Books Bought
Jeff
717-325-6907

D1237761

5

Books Bought
Jeff
717-325-6907

**FEDERICO ZERI** (Rome, 1921-1998), eminent art historian and critic, was vice-president of the National Council for Cultural and Environmental Treasures from 1993. Member of the Académie des Beaux-Arts in Paris, he was decorated with the Legion of Honor by the French government. Author of numerous artistic and literary publications; among the most well-known: *Pittura e controriforma*, the Catalogue of Italian Painters in the Metropolitan Museum of New York and the Walters Gallery of Baltimora, and the book *Confesso che ho sbagliato*.

## Work edited by FEDERICO ZERI

**Text**
based on the interviews between
FEDERICO ZERI and MARCO DOLCETTA

This edition is published for North America in 2000 by NDE Publishing*

**Chief Editor of 2000 English Language Edition**
ELENA MAZOUR (*NDE Publishing**)

**English Translation**
SUSAN SCOTT

**Realization**
ULTREYA, MILAN

**Editing**
LAURA CHIARA COLOMBO, ULTREYA, MILAN

**Desktop Publishing**
ELISA GHIOTTO

ISBN 1-55321-013-1

**Illustration references**

**Alinari Archives:** 4b, 41as.

**Bridgeman/Alinari Archives:** 18, 23s, 27ad-bd, 28ad-bd, 28-29, 29s-d, 30s-ad, 37b, 39, 43 bs-ad, 44/VI-VII, 45/II-III-VII.

**Giraudon/Alinari Archives:** 5s.

**Luisa Ricciarini Agency:** 6s-ad, 8bd, 9s, 15d, 16s, 20s, 20-21, 30-31b, 38-39, 40a, 41bd, 44/IV-VIII.

**RCS Libri Archives:** 1, 2bs, 3, 4a, 5d, 7, 8a-bs, 9d, 1a-b0, 11, 12-13, 13bd-bs, 14a, 14-15, 16b, 16-17, 17as-ad-c-bs, 18-19, 19sd, 20ad-bd, 22-23, 23d, 24ad-bd, 25, 26-27, 27bs, 28as-bs, 30c, 31d, 32, 32-33, 34, 35b, 36, 36-37, 38 s-d, 40b, 41ad, 42, 43 as-bd, 44/I-II-III-IX-X-XI-XII, 45/I-IV-VI-VIII-IX-X-XI-XIII-XIV.

**R.D.:** 2as-bd, 2-3, 6bd, 13a, 15as, 17bd, 24s, 27 as, 31s, 35a, 37a, 41bs, 44/V, 45/V-XII.

Printed and bound by Poligrafici Calderara S.p.A., Bologna, Italy

*a registered business style of NDE Canada Corp.
15-30 Wertheim Court, Richmond Hill, Ontario
L4B 1B9 Canada, tel. (905) 731-1288*

*The captions of the paintings contained in this volume include, beyond just the title of the work, the dating and location. In the cases where this data is missing, we are dealing with works of uncertain dating, or whose current whereabouts are not known. The titles of the works of the artist to whom this volume is dedicated are in blue and those of other artists are in red.*

# KLIMT
# JUDITH I

In JUDITH I, as in most of Klimt's works, we have before us a transfiguration. While the faces maintain a semblance of naturalism, albeit with dreamy, often almost hypnotic expressions, they are immersed

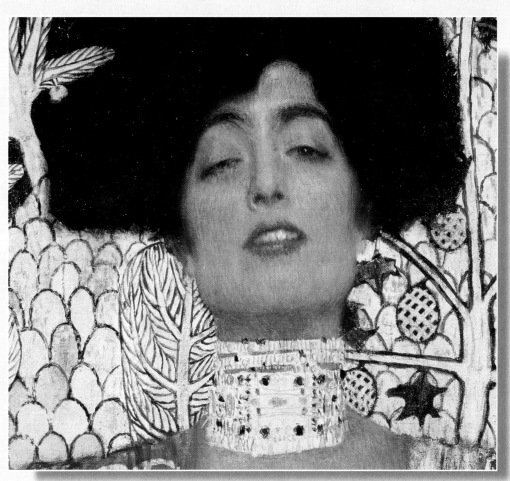

in a completely abstract context, one that with characteristic decorativism announces that Art Nouveau has by now been left behind.

# THE SEDUCTIVENESS OF AN AMBIGUOUS HEROINE

## JUDITH I

*1901*

● Vienna, Österreichische Galerie (oil on canvas, 84x42 cm)

● The title of this work is inscribed in large letters at the top of its embossed copper frame, which was made by Georg Klimt. The subject is taken from the Bible, the story of a young heroine who, during the war between the city of Bethulia and the Assyrian king Nebuchadnezzar, pretends to yield to the bloodthirsty enemy general Holofernes, then, deceiving him about her intentions, beheads him. Thus in painting tradition Judith becomes a symbol of beauty triumphing over brute force.

● The languid interpretation presented by Gustav Klimt hovers between a faithfulness to and a complete overturning of the Biblical text. At first glance, the sensual image calls more to mind the episode of the beheading of John the Baptist requested by Salome, whose allure and erotic provocativeness places her at the opposite pole from the virtuous Judith. Her self-centered whim acts as a counterbalance to the altruistic motives which drive Judith to murder.

● Klimt painted a second version of the subject in 1909, which from its very title makes explicit the affinity with Salome. Nonetheless, the passage from the Bible justifies in some way the iconographical ambiguity exploited by the painter, as it says that before going to her appointment with Holofernes, the heroine dressed herself in her most precious jewels and veils to enhance her beauty and sensuousness.

● The picture, which aroused a great outcry in Vienna and was purchased by the painter Ferdinand Hodler, is profoundly immersed in the climate of decadentism that was widespread around the turn of the twentieth century. The theme of the woman as cruel seductress inspired music and literature of the time as well, a supreme example being Oscar Wilde's play *Salome* with music by Richard Strauss. Wilde's play had been published in London in 1894 with illustrations by Aubrey Beardsley, in which the artist – moving in the opposite direction from Klimt – had melded in an elegant linear style the positive charm of Judith with the erotic cruelty characteristic of Salome.

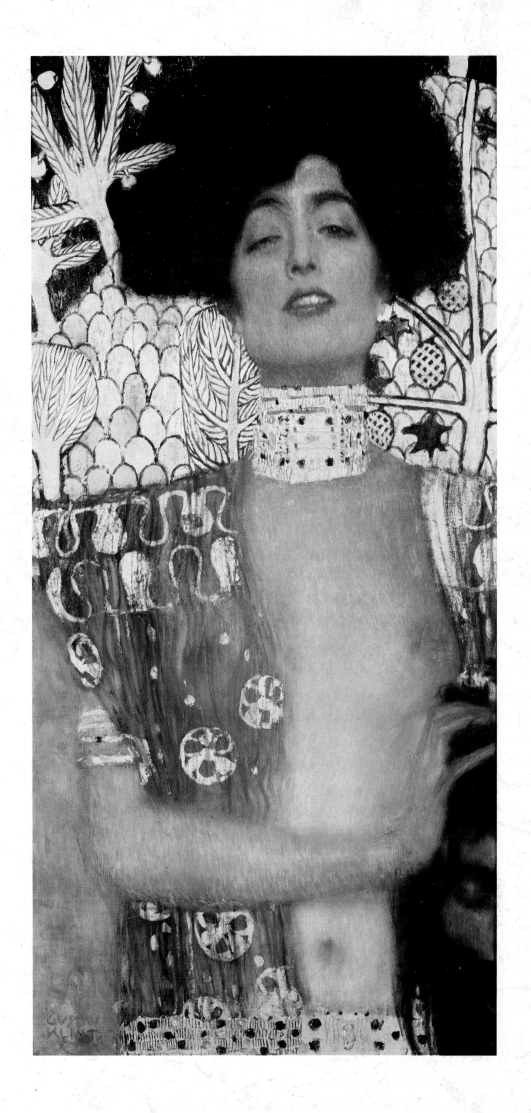

# THE MOTIF OF JUDITH AND HOLOFERNES

When Klimt approached the Biblical theme of Judith for the first time, a preferential reading of the subject had already taken shape and become canon. The numerous canvases depicting the episode utilize a narrative form of representation in which every detail expresses her heroism and glorifies her virtue. At her side usually ap-

◆ SANDRO BOTTICELLI
*Judith's Return to Bethulia*
**(c. 1470, Florence, Uffizi)
The painter describes the Biblical scene in a narrative manner, recreating the battle scene in the background to explain the motive for Judith's action. The young woman's tormented face contrasts with the haughty expression proposed by Klimt.**

pears the older, faithful handmaiden, whose task it is to dispel any uncertainty or hesitation Judith might feel.

● Judith appears as the instrument of salvation decreed by God, one which she cannot escape, but the violence of her crime terrifies her as well, to judge from the expression of disgust that Caravaggio paints on her face. With the exception of this artist who reconstructs the dramatic moment of the actual beheading, tradition has dwelt instead on the moment afterwards, when the still incredulous young woman holds in her hand the severed head of Holofernes.

● Klimt deliberately ignores every reference to narrative and focuses on Judith alone, to the point of cutting the man's head in half with the edge of the picture. There is no trace of the sword, as though the heroine might have used a different weapon. This omission helps justify the association with Salome. The moment before the murder, the phase of the general's seduction, seems to fuse with the conclusion of the story.

● *Judith I* reveals a curious symbolic and compositional consonance with Von Stuck's *Sin*: the temptation described by the German artist becomes the model for Klimt's *femme fatale* in its utilization of the nude evanescent body as the focal center of the canvas, and in the ambiguity of the face.

● The force that Judith exudes derives from the close-up view and the solidity of her pose, built around right angles. The verticality of her body and Holofernes's head is matched by the parallel horizontals of the lower edge of the picture, her arm, her shoulders united by her necklace, and the bottom line of her hair.

◆ **GUSTAVE MOREAU**
*Orpheus*
(1865, Paris,
Musée d'Orsay).
Moreau prefigures
in his representation
of the myth of Orpheus
the opulent elegance
proposed by Klimt
in *Judith*.

◆ **A SLEEPING FACE**
The macabre meaning
of the head
in relationship
to the allusive
sensuality
of the woman
represents
the decadent pairing
of love and death.
Klimt's characteristic
refinement keeps him
from giving a crude
description of
the whole head and
leads him to depict
only a detail, relegated
to the margin.
The woman's
sensuousness
emanates from an
ethereal creature,
almost as though
she were lacking
flesh and blood.

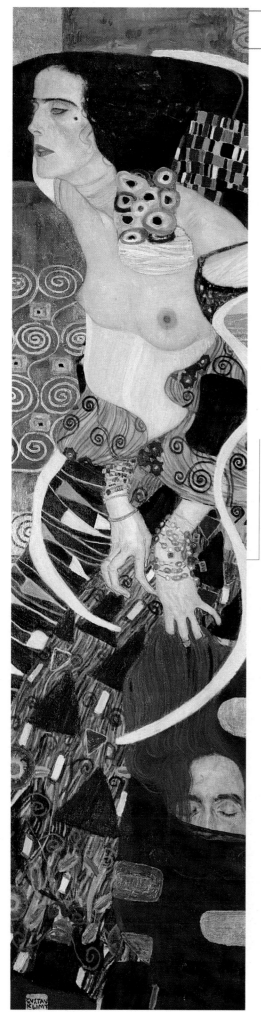

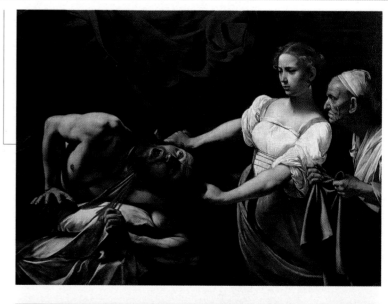

◆ CARAVAGGIO
*The Beheading
of Holofernes*
(1599, Rome,
Palazzo Barberini).
Caravaggio's
tragic vein captures
the culminating
moment of Judith's act,
intensifying it through
the macabre details
of the blood and
the expression on
Holofernes's face.
The heroine's
determined gesture
is contradicted
by her horror, which
forces her to pull back
as far away as possible
from the man.

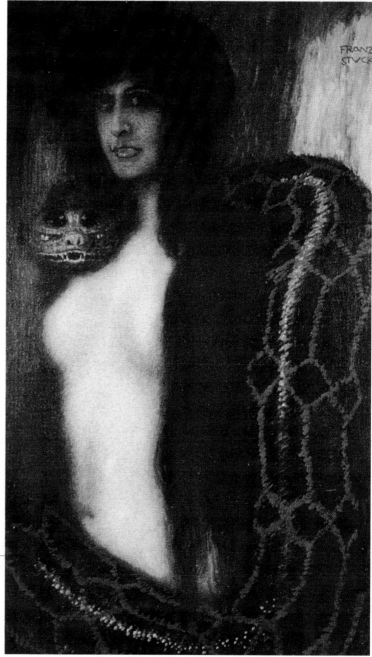

◆ JUDITH II
(SALOME)
(1909, Venice, Galleria
d'Arte Moderna).
In this second version
Klimt further unites
the roles of Salome
and Judith in a hybrid
heroine with a rapacious
air, whose nudity
is here explicit, in
contrast to the veiled
nudity of the first
picture. Holofernes,
more than a warrior,
seems now to be
the victim of a merciless
female power.

◆ FRANZ VON STUCK
*Sin*
(1899, Palermo, Galleria
d'Arte Moderna).
The literary element,
omnipresent
in the painting
of the German artist
Von Stuck, is evident
here in the snake
embodying
the danger that marks
this *femme fatale*,
compared
to the temptress
described by Klimt.

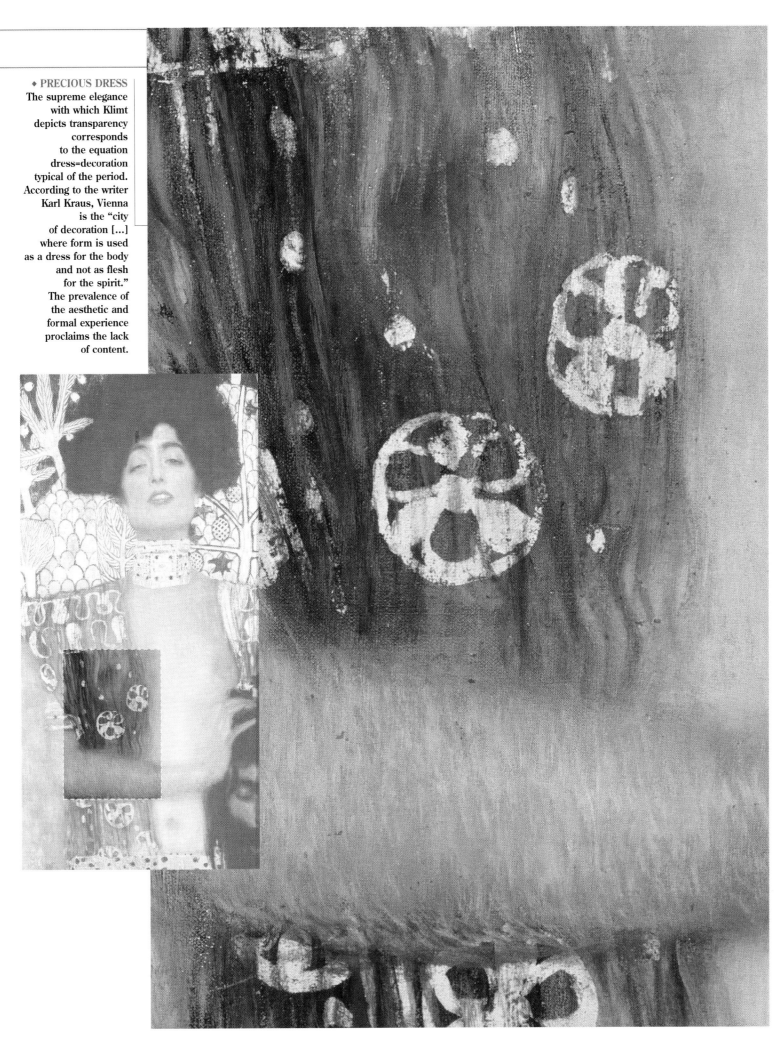

◆ PRECIOUS DRESS
The supreme elegance
with which Klimt
depicts transparency
corresponds
to the equation
dress=decoration
typical of the period.
According to the writer
Karl Kraus, Vienna
is the "city
of decoration [...]
where form is used
as a dress for the body
and not as flesh
for the spirit."
The prevalence of
the aesthetic and
formal experience
proclaims the lack
of content.

# THE FACE AND THE GAZE

Judith's face contains a mixture of voluptuousness and perversion. Her features are transfigured so as to reach the highest degree possible of intensity and seductiveness, which Klimt achieves by placing the woman in an unreachable dimension. Despite her altered physiognomy, she can be recognized as the painter's friend and perhaps lover Adele Bloch-Bauer, of whom he made two portraits in 1907 and 1912. She is the same upper middle class society hostess who had lent her countenance also to the *Pallas Athene* of 1898.

● The slightly lifted and proudly held head contradicts the apparent surrender of her languid gaze and red, half-parted lips, suspending seduction between challenge and invitation. The contrast between her black hair and the golden luminescence of the background exalts the elegance and opulence of the surface. Her contemporary hairstyle is accented by the stylized motifs of trees spreading fan-like on either side.

● In the 1901 version the woman's face has a magnetic charm and sensuality that yield in *Judith II* to a harsher treatment of the features and a more pitiless expression. In its formal qualities, more than of an avenger, the picture seems almost to be of a sorceress, the disturbing enchantress pursued by Symbolists writers and painters from Wilde to Moreau.

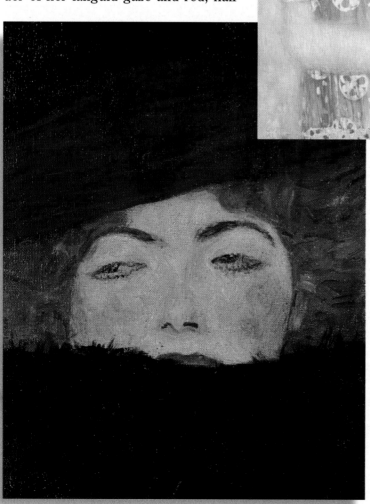

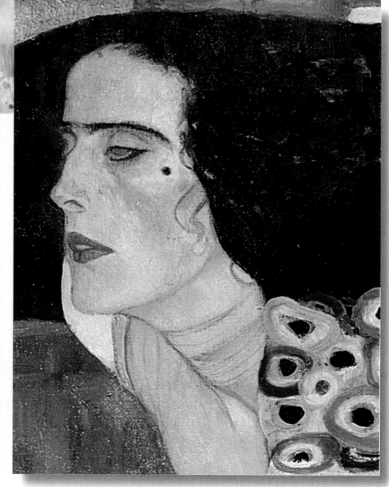

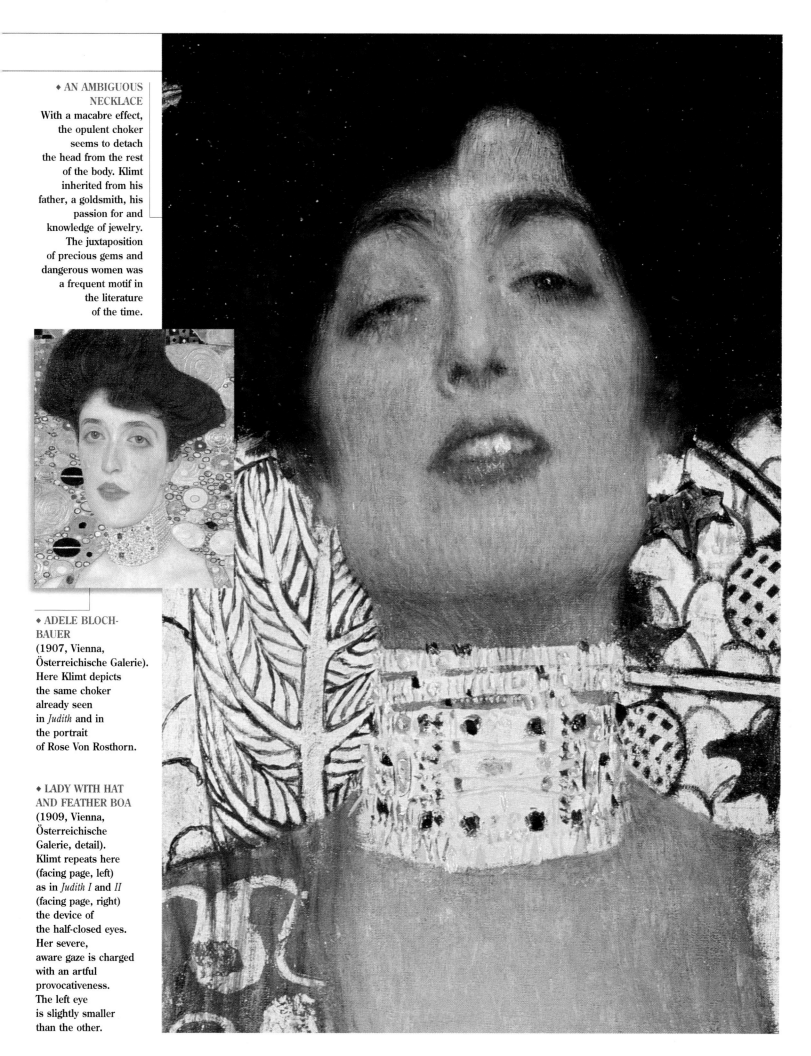

**◆ AN AMBIGUOUS NECKLACE**
With a macabre effect, the opulent choker seems to detach the head from the rest of the body. Klimt inherited from his father, a goldsmith, his passion for and knowledge of jewelry. The juxtaposition of precious gems and dangerous women was a frequent motif in the literature of the time.

**◆ ADELE BLOCH-BAUER**
(1907, Vienna, Österreichische Galerie). Here Klimt depicts the same choker already seen in *Judith* and in the portrait of Rose Von Rosthorn.

**◆ LADY WITH HAT AND FEATHER BOA**
(1909, Vienna, Österreichische Galerie, detail). Klimt repeats here (facing page, left) as in *Judith I* and *II* (facing page, right) the device of the half-closed eyes. Her severe, aware gaze is charged with an artful provocativeness. The left eye is slightly smaller than the other.

# A SHOWER OF GOLD

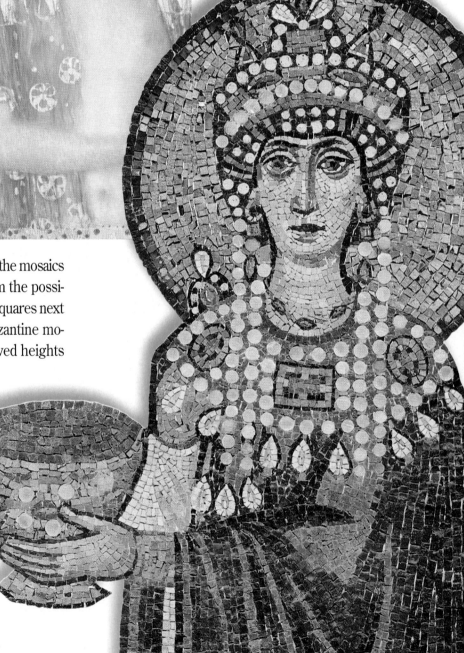

The most striking element in Klimt's entire production lies in his curious way of inserting naturalistic details (faces and hands more than full figures) into a world of pure abstraction, where the force of the image is entrusted to a stylized, surface decorativism.

● Klimt attacked his paintings with a sort of *horror vacui*, filling every square inch with vegetable motifs, geometrical arabesques, splashes of bright color. It has been said that this maniacal attitude corresponds to an existential emptiness that arises in times of decadence and thus is destined to re-emerge every time history and values enter into a phase of crisis. Certainly Klimt's insistence on perfecting the splendor of his portraits nullifies any introspective intent or any biographical connotation of the figures, placing them in a golden limbo.

● Greek vase painting and abstract wall decorations offered Klimt the richest repertory of stylized forms, more than Art Nouveau – from which he does borrow. But it was the mosaics in Ravenna discovered in his youth that showed him the possibilities opened to an artist by putting minute colored squares next to each other. He measured himself against the Byzantine mosaicists, who, using a fragmentary technique, achieved heights of shimmering light effects and symbolic intensity.

● Klimt absorbed their heritage of the dominance of gold, but without the connotations of religious transcendence attributed it by Byzantine culture. For him it answered to his demands for aesthetic opulence, as it exalted the art of pictorial inlay, but at the same time it took on a strong allusive charge, one that could easily lend itself to erotic overtones. But we must also not forget that the artist had studied in a school of applied arts, where he learned to be a goldsmith. For him, there is no distinction between the so-called minor and major arts. As the art historian Alios Riegl wrote in 1893 in *Questions of Style*, ornamentation is a fundamental, and above all spontaneous, pictorial instrument, not a matter of sheer craftsman's technique, to which every epoch entrusts its own particular expressive intent.

◆ THE BACKGROUND

The golden scales
motif, already seen
in the breastplate worn
by *Pallas Athene*,
of 1898, plays an
important role in this
picture, highlighting
Judith's face with its
glow. The stylized
silhouettes of trees
open fan-like,
as though in a visual
echo of her hairstyle,
or are unnaturally
forced into simplified
outlines, enlivening
the shimmering surface
of the gold with
the rhythmic contrast
of their lines.

◆ THE SEDUCTIONS
OF THE EMPRESS
THEODORA
(Ravenna, San Vitale,
6th century A.D.,
detail). Klimt was
fascinated by
the splendor of
the Byzantine mosaics,
which unite the worldly
magnificence
of the court at
Constantinople
with a yearning for
transcendence.
He admired
the chromatic play
of the brilliant colors,
the golden luster
of the *tesserae*,
the versatility of
combination of colors
and gold to exalt,
for example, the jewels
worn by the empress
Theodora.

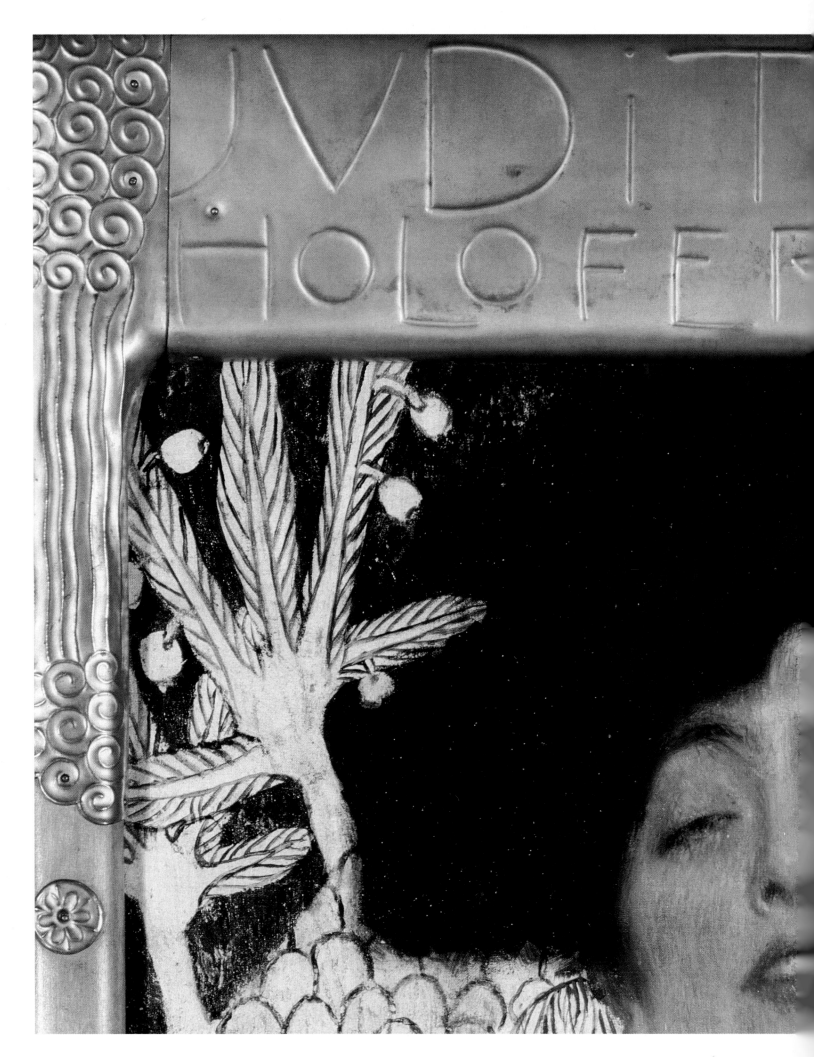

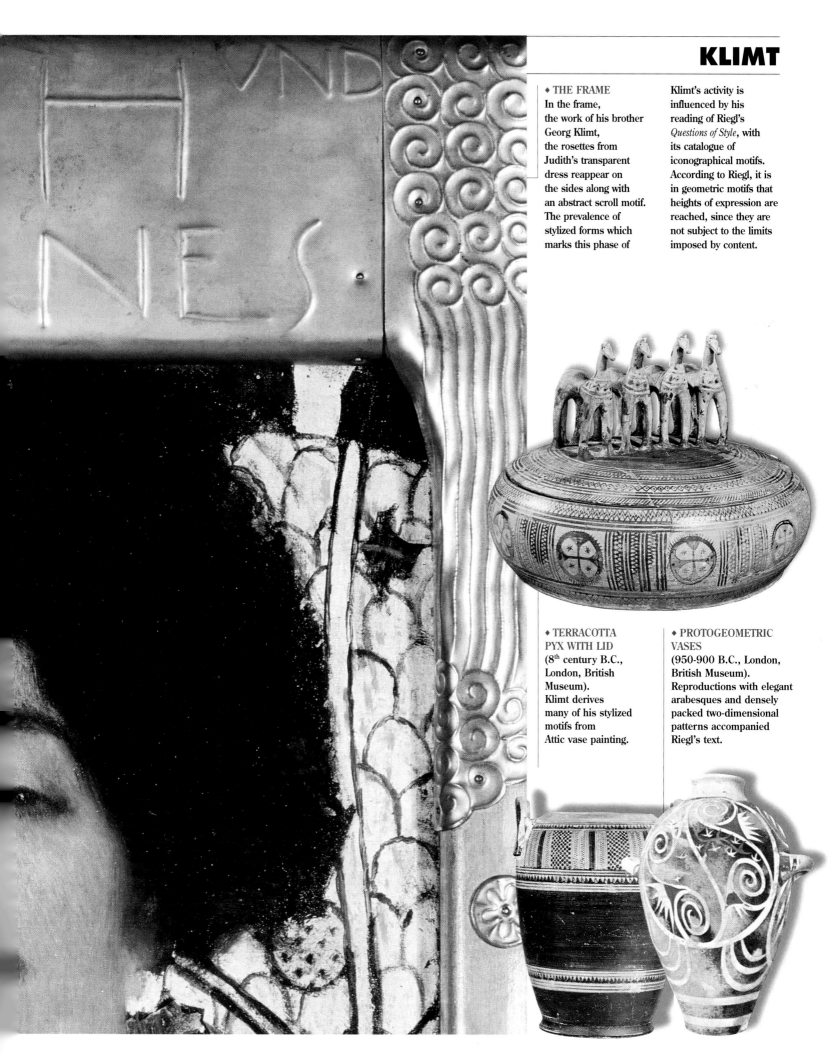

◆ THE FRAME
In the frame,
the work of his brother
Georg Klimt,
the rosettes from
Judith's transparent
dress reappear on
the sides along with
an abstract scroll motif.
The prevalence of
stylized forms which
marks this phase of

Klimt's activity is
influenced by his
reading of Riegl's
*Questions of Style*, with
its catalogue of
iconographical motifs.
According to Riegl, it is
in geometric motifs that
heights of expression are
reached, since they are
not subject to the limits
imposed by content.

◆ TERRACOTTA
PYX WITH LID
(8th century B.C.,
London, British
Museum).
Klimt derives
many of his stylized
motifs from
Attic vase painting.

◆ PROTOGEOMETRIC
VASES
(950-900 B.C., London,
British Museum).
Reproductions with elegant
arabesques and densely
packed two-dimensional
patterns accompanied
Riegl's text.

# "TO EVERY AGE ITS ART, TO EVERY ART ITS FREEDOM"

Klimt interpreted in painting the magnificence of *fin de siècle* Vienna. Very little is known about his life, but a biographical and ideological profile can nontheless be traced through his works and the sensation and enthusiasm they aroused. Thanks to his talent, he was able to rise above his modest family origins to reach the top of the artistic hierarchy, and was awarded the Gold Cross for artistic merit by the emperor, along with numerous commissions.

● The elegant society which Klimt portrayed in its evenings at the theater made him a witness to imperial splendor and its protagonists. And yet, he was well aware of the lack of historical substance and the psychological fragility behind this facade. Freed from the burden of tradition which that world imposed, he dared to push forward, toward an authentic art. Klimt wanted to create a modern style which no longer expressed reverence toward the past but the excitement and the spirit of the modern age. To an eclectic, sterile revival he opposed the expressive dignity of the pre-

sent. Thus he completely overturned his artistic sources with an unexpected ornamentation aimed at exalting feminine charm and at accompanying his introspective investigation, which probed the inner essence as well as the social exterior of his subjects.

● Under the thrust of this drive, Klimt founded in 1897 the Vienna Secessionist movement, a sort of counterpart to French *Art Nouveau*. His aim was to re-establish the prestige of painting with respect to the music and theater then dominating the cultural panorama. Using exhibitions and other promotional activities, he pursued his dream of furnishing a model for the transformation of society. With the Secession experimentation, he also hoped to free Austrian art of its parochial provincialism, moving it onto an international plane.

◆ THE SECESSIONISTS (Vienna, Bildarchiv der Österreichischen Nationalbibliothek). The photograph depicts the participants in the 14th exhibition of the Secessionist movement; Klimt is sitting in the chair. One of the leading protagonists is absent, the architect Joseph Maria Olbrich (1867-1908), one of the principal founders of the movement. With the money raised by the movement's first shows, Olbrich built the new Secession pavilion (above, 1898), in which he combined clear geometric forms with a virtuoso *Art Nouveau* dome, repeating the same motifs along the walls.

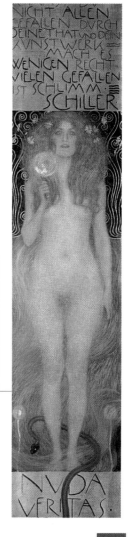

♦ THE ARTIST'S STUDIO
Klimt's *atelier* reveals how the painter worked on more than one canvas at the same time. In this, his last studio, an austere environment contrasts with the glorious profusion of figures and ornamentation found in his works.

♦ NUDA VERITAS (1899, Vienna, Museum des 20, Jahrhunderts). Schiller's message is an incitement to action, while the flowers in the model's hair and at the bottom of the picture allude to the regenerating force of the truth. The mirror represents an invitation to self-knowledge: "Only in art is there truth, all the rest is a play of mirrors" (Hofmannsthal).

## THE SECESSION

Founded in 1897, the Secession constituted an occasion for encounter for all those, whethers artists, writers or musicians, who proclaimed their dissatisfaction and felt the need for a cultural renewal. As Schorske pointed out, it was not a new *Salon des réfusés* for those who were excluded from the official art world, but rather a movement with something to offer, which saw Klimt as one of its founders and its first president (1897-1905). Among its promoters were artists like Carl Moll and Koloman Moser, and the architects Joseph Olbrich, Joseph Hoffman, and Otto Wagner, who was responsible for the motto "We must show modern man his face."

To disseminate their new ideas, a journal was founded entitled *Ver Sacrum*. Published until 1903, it embodied even in its form the aspiration to a total art proclaimed by Wagner and the Secessionists.

In his artistic production, Klimt was often forced nonetheless to come to terms with the political world. An example is the episode of the frescoes painted for the University, when his free interpretation of the subjects caused a sensation and sanctioned the rupture between Klimt and official art.

# DECORATIVE EXUBERANCE

The gift for decoration which unifies all of Klimt's production derives not only from his observation of his father's work as a goldsmith, but also from his early training at the School of Applied Arts in Vienna. Here he learned various techniques ranging from mosaic to fresco,

♦ **THE KISS**
(1907-08, Vienna,
Österreichische
Galerie).
In an unreal,
languid dimension,
two completely two-
dimensional bodies
exchange a chaste kiss.

but above all he learned to conceive all of reality as the arena of artistic experimentation. Klimt would say that "No area of human life is so insignificant or trivial that it cannot offer scope for artistic endeavor."

● From the Symbolist evanescence of his early works to the biomorphic flowerings of his last, his decorative formula must not be confused with a frivolous kind of aestheticism. Its sources lie in the immense repertory accumulated during his apprenticeship: from Greek vase painting to Egyptian stylization, from Byzantine mosaics to folk art. The meticulously described opulence of his details, as well, shows his careful study of the art of the past and echoes the style of Gentile da Fabriano.

● Nonetheless, the phase of his heavy use of gold, introduced by *Judith I* of 1901 and reaching all the way to *Judith II* of 1909, can be viewed as a moment in itself. The domination of gold marking his canvases done during this period derives from a need for transfiguration, a desire to sublimate the data of reality. As Byzantic mosaics demonstrate, gold is the preferred symbol of transcendence. But Klimt uses it with a structural intent, using the shimmering inlaid surface to counterbalance the lack of volume of the forms and to infuse an aura of magic into the fascination they exude, as deliberately sought as it is arcane.

♦ **EXPECTATION**
(1905-09, Vienna,
Österreichisches
Museum für
angewandte Kunst).
Klimt prepared this
cartoon for the mosaic
frieze in the dining
room of Stoclet Palace
in Brussels.

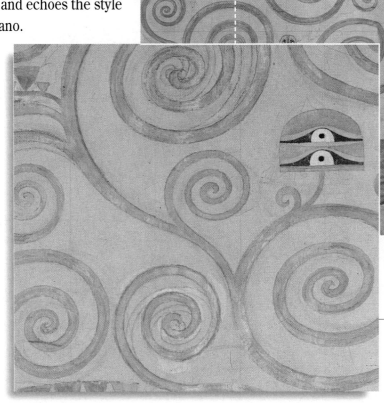

♦ **TENDRILS**
The scroll motif
running
along the walls
suggests
the tendrils
of a symbolic
tree of life,
used as the unifying
thematic and
formal thread for
the entire frieze.

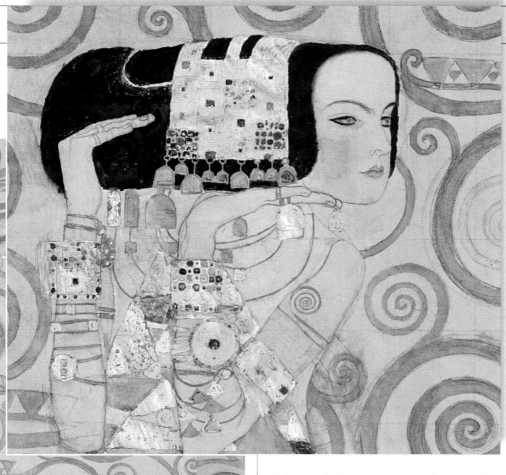

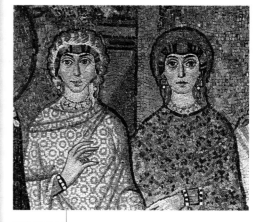

**♦ THE LADIES-IN-WAITING**
(6th century A.D., Ravenna, San Vitale, detail). After studying the mosaics from books, in 1903 Klimt went to Ravenna, where he found new decorative motifs for glorifying his figures.

**♦ GENTILE DA FABRIANO**
*The Adoration of the Magi* (1423, Florence, Uffizi). The taste for narration and naturalism typical of the Late Gothic style here is united with the Byzantine love of gorgeous surface decoration.

**♦ A HYBRID FACE**
The personification of expectation is striking for the curious combination of two stylistic referents. Her pose is unmistakably borrowed from Egyptian wall decorations, with its unnatural torsion which throws back onto the surface the figure's plastic form. But her decidedly stylized profile and elongated eyes and eyebrows echo the Japanese figurative tradition.

**♦ THE VAULT OF HEAVEN**
(6th century A.D., Ravenna, Mausoleum of Galla Placidia, detail). The inlay, which plays on the contrast in light effects between the dark blue night sky and the gold of the stars, vibrates with its unexpected forms. Removed from its context, the mosaic seems not so much a starry night as an ornamental motif.

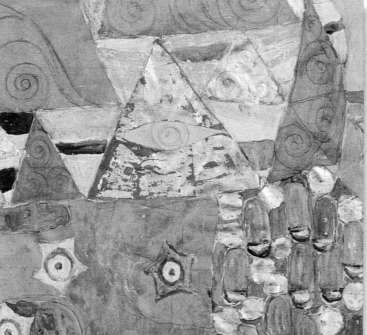

**♦ THE EYE MOTIF**
The sacred eye is taken from the Egyptian myth of the God Horus, with its significance of regeneration. It is inscribed in a triangle on the figure's dress, and in the background appears as a double flower among the tendrils.

# EROS AND THANATOS

The splendor of Viennese society represents only the positive pole of Klimt's work; its opposite end can be found in his themes hovering between existential pessimism and biological evolutionism.

● In his early works the life cycle appears in allegorical form, immersed in a dreamy atmosphere. But after his break with official art and his resulting crisis, the painter moved toward a darker view.

● Klimt now achieves an unexpected capacity for introspection, especially in dealing with basic feelings like motherhood and love. But a tragic note of caricature emerges with the figures piled together in contorted embraces to express an inconsistent celebration of life. In the dissolution of form into ornamental texture lies the decadence of a world.

Klimt's universe focuses on woman as an unhealthy, obsessive idol and takes up the guantlet already thrown down to moralism by Schnitzler and Hofmannsthal, by the misogynism of Weininger or the erotic drive of Freud. Thus we have bodies disintegrated or reabsorbed in a strongly allusive decorativism, but in the human being's eternal process of becoming, even the ambiguous erotic power of the *femme fatale* yields to the spectre of death.

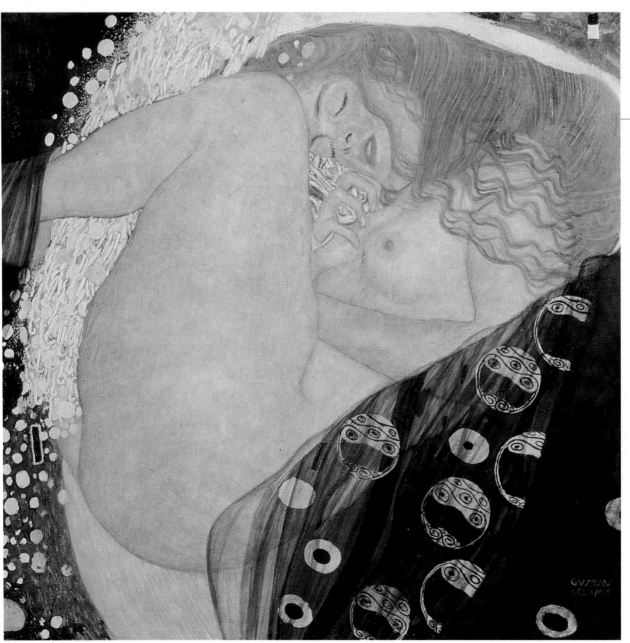

◆ DANAE
(1907-08, Vienna, private collection).
The apparent innocence of the sleeping figure is belied by her pose and the gesture of her hand, both of which express a powerful sensual charge. Jove, who came down to Danae in the form of a golden shower, was unable to resist.

◆ GOLDFISH
(1901-02, Solothurn, private collection).
The pose of the female figure recalls Rodin's model, but it unites with the elegance of the sculpture a deliberately provocative intent, evident in the languid glance turned towards the viewer. For Klimt, woman was like a Janus with two faces, one seductive and the other demonic. The water as well, by association, leads into an erotic imaginary universe.

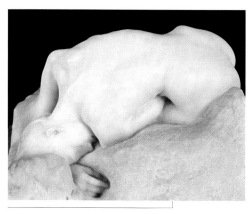

♦ AUGUSTE RODIN
*Danaïd*
(1886, Paris,
Musée Rodin).
The purity of the form
is charged with
a strongly erotic suggestiveness, even
though the pose is
absolutely chaste.
The French sculptor's
work profoundly
influenced his
contemporaries.

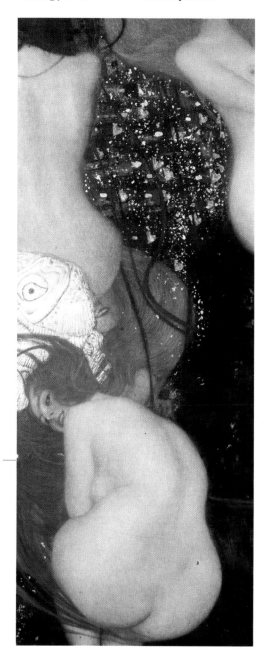

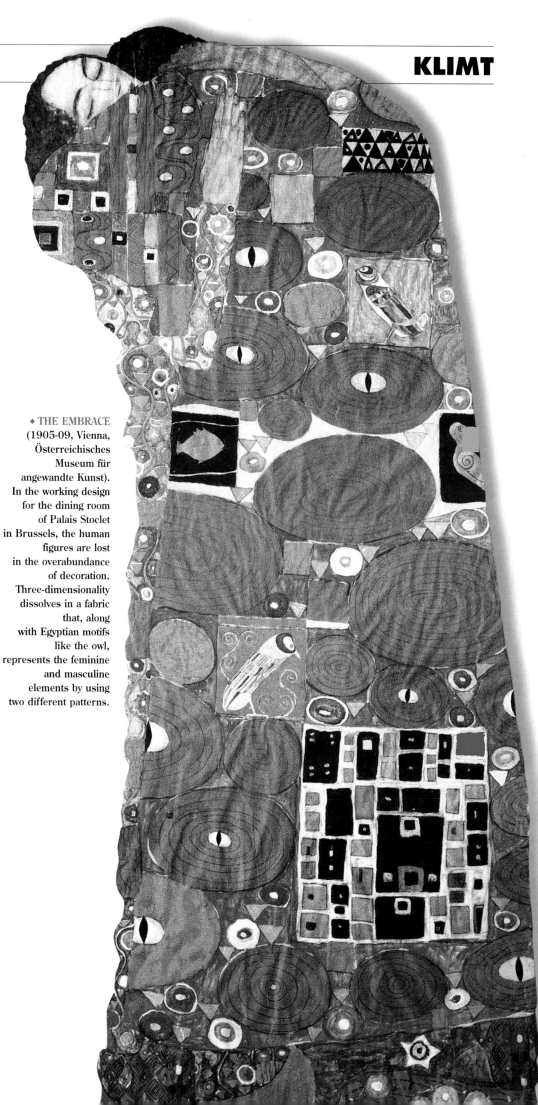

♦ THE EMBRACE
(1905-09, Vienna,
Österreichisches
Museum für
angewandte Kunst).
In the working design
for the dining room
of Palais Stoclet
in Brussels, the human
figures are lost
in the overabundance
of decoration.
Three-dimensionality
dissolves in a fabric
that, along
with Egyptian motifs
like the owl,
represents the feminine
and masculine
elements by using
two different patterns.

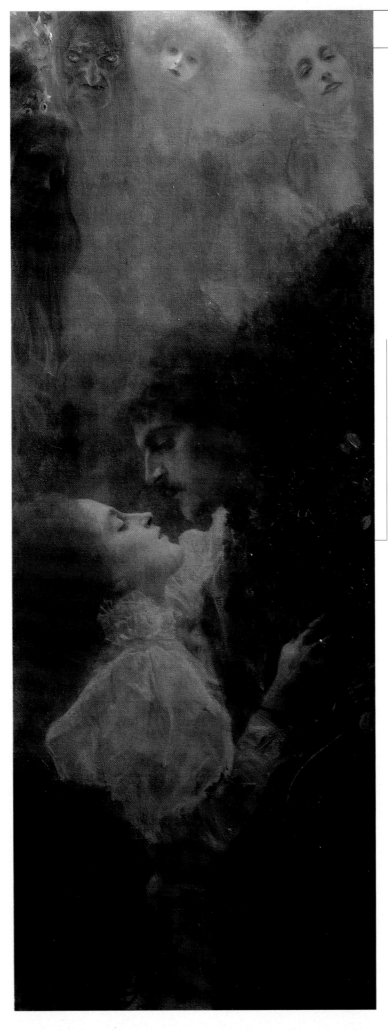

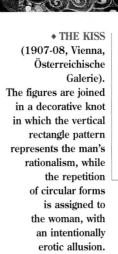

◆ THE VIRGIN
(1912-13, Prague,
Národni Galerie).
In the tangle
of figures and circular
motifs already seen
in *The Kiss*,
Klimt portrays
the woman's state
of expectation.
He alludes to eroticism
with the symbolism
of the shell and
the black moon in
the ornamentation.

◆ LOVE
(1895, Vienna,
Historisches Museum
der Stadt Wien).
The work belongs to the
symbolist phase of
Klimt's activity and
interprets in
an idealized atmosphere
a pre-Raphaelite theme.
The trembling approach
of the two faces toward
each other conceals
a veiled seduction
expressed as the pure
desire of the two lovers.
The allegory of love is
shown here as a vibrant
psychological agitation.
A melancholy note
looms over the apparent
happiness of the image
with the heads
at the top. They are
the symbol of the
different phases
of life and allude
to the fleeting nature
of the joys of love.

◆ THE KISS
(1907-08, Vienna,
Österreichische
Galerie).
The figures are joined
in a decorative knot
in which the vertical
rectangle pattern
represents the man's
rationalism, while
the repetition
of circular forms
is assigned to
the woman, with
an intentionally
erotic allusion.

◆ THE BEETHOVEN
FRIEZE
(DETAIL OF THE
HOSTILE FORCES)
(1902, Vienna,
Österreichische
Galerie).
Klimt underlines
the component of female
provocation and
domination, which is
made grotesquely
explicit by the insertion
into the scene
of the chimpanzee.

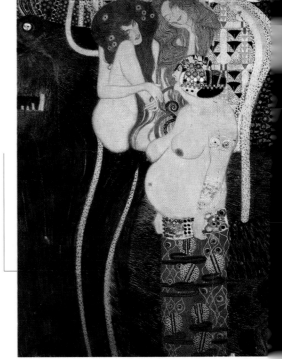

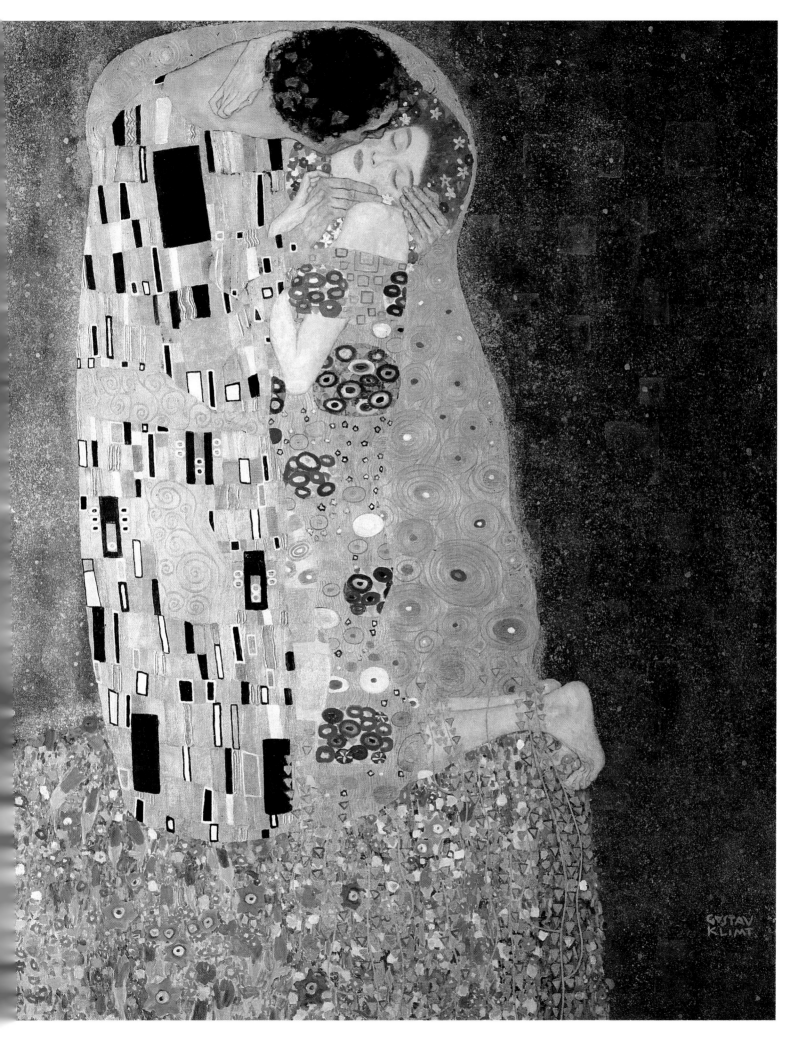

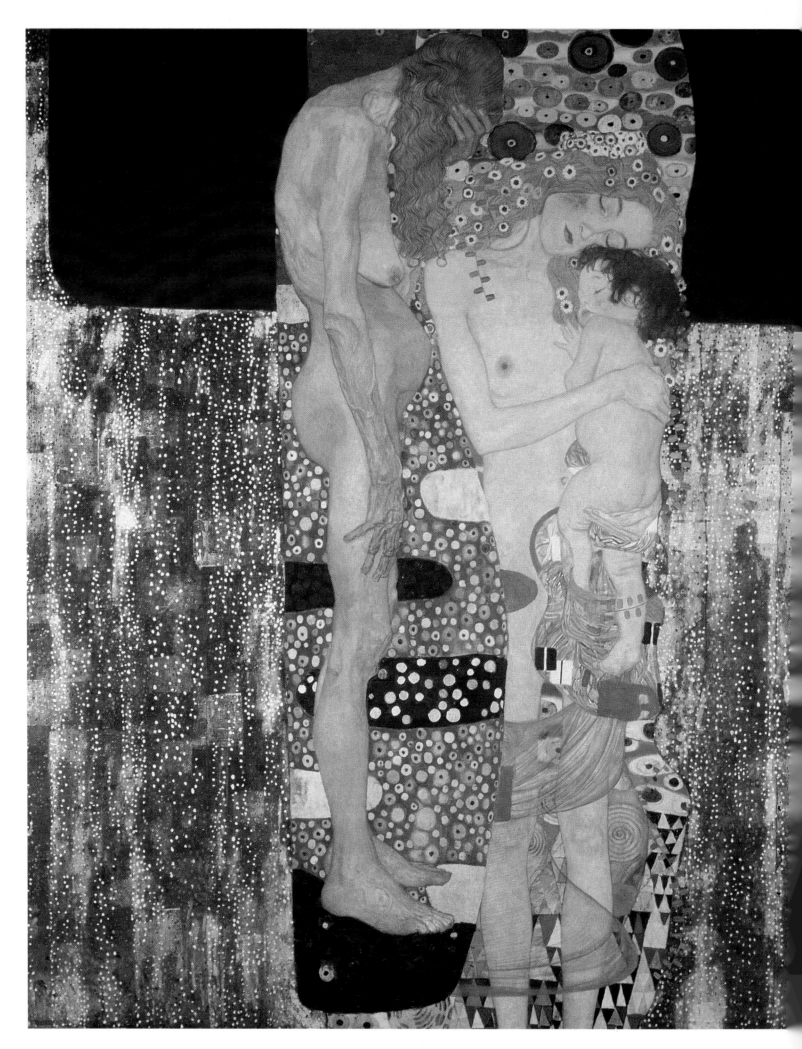

◆ THE THREE AGES
OF WOMAN
(1905, Rome,
Galleria Nazionale
d'Arte Moderna).
The usual crowding
of figures into
the compositions
is here reworked as
the juxtaposition of
three female figures
against a dark, empty
background. The crude
realism of the old
woman, whose drama
is intensified by her
expressive gesture,
is followed by
the sweetness of
the mother, whose
burnished body
maintains its unaltered
charm. The body
of the old woman,
deformed by age, is
counterposed by the
elegance of the young
woman and the secure
abandon of the child.

◆ HOPE I
(1903, Ottawa, National
Gallery of Canada).
This is one of
the few paintings
in which the human
body is not altered
by the decorative intent,
but has an unexpected
three-dimensionality.
The scandal
of the pregnant nude
is aroused not only
by the realism with
which it is portrayed but
also by its juxtaposition
with demon-like figures,
which do not symbolize
a Satanic maternity but
rather the obstacles
which the burgeoning
life will have
to overcome. Birth
naturally leads to death,
as is revealed by
the flowers going from
the woman's head
toward that
of the monster.

◆ DEATH AND LIFE
(1906-11, Vienna,
private collection).
Compared to
the serenity of
*The Three Ages of Woman*,
here a tragic and
profoundly dark vein
dominates.
The intertwined
sculptural bodies under
a brightly colored cover

trace crucial stages
of human existence,
like love and
motherhood.
This is counterbalanced
on the left by
the unsettling
solitude of death,
whose menacing
aspect is accentuated
by the crosses
on its body.

# LANDSCAPE

Klimt came to landscape fairly late, between 1900 and 1916, coinciding with the ideological crisis which struck him in the first decade of the century. He went to the lake of Attersee looking for a moment of relief, and found it by painting *en plein air*, following the example of the Impressionists. But, unlike the painters of that school, Klimt chose to celebrate the beauty of nature in its infinite variety, not to attempt to reproduce it faithfully or to study its effects of light.

● Compared to his human subjects and their content of ambiguity, Klimt's landscapes are imbued with an intimate feeling which soothes the eye in a lyrical vision of nature. Atmospheres of harmonious serenity or melancholy solitude are pervaded by a silence at times solemn, at others nostalgic. The image appears very close up, boldly framed, with a high horizon when there is one at all, which completely immerses the spectator in the landscape.

● As in *Beech Forest I*, the composition is sometimes structured in a rhythmic play of verticals and horizontals which prevents the observer from calculating the proportional relationships between the elements. The eye is lost in the teeming colors, in the myriad flicks of the brush which only at a distance acquire a recognizable form. The brushstroke, still reminiscent of mosaic surfaces, is reduced to a sort of *pointillisme* which Klimt had discovered in Seurat during his recent trips to Paris. The delicate handling of the pigment makes the entire landscape shimmer, enlivening it in a dense chromatic tapestry effect with a sumptuousness that echoes the multiform richness of nature.

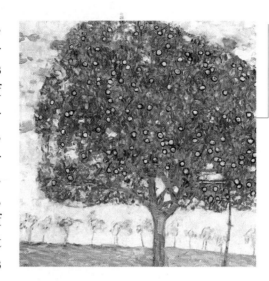

◆ THE APPLE TREE II (c. 1916, Vienna, Österreichische Galerie).
The tree, which foreshadows Mondrian's stylization, appears circumscribed in a simplified, not completely natural silhouette, echoed by the regular rhythm of the shapes relegated to the horizon.

◆ KLIMT IN HIS GARDEN
In the photograph to the left, Klimt is portrayed in a corner of the garden of his atelier on Josefstädterstrasse in Vienna. The painter was not fond of crowds or of modern city life. His solitary nature found comfort in taking care of plants and flowers, from which he often took inspiration for his pictures.

◆ THE BEECH FOREST I (1902, Dresden, Gemäldegalerie Neue Meister).
The canvas is square; Klimt chose this format for almost all his landscapes, feeling that it was the best suited for transmitting a sense of balance. Despite the dense network of beech trees and the range of primary colors, the work is steeped in an atmosphere of solitude.

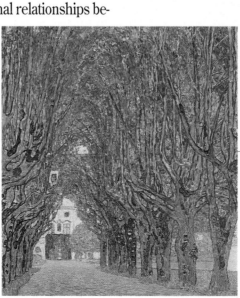

◆ AVENUE IN THE PARK OF THE SCHLOSS KAMMER (1912, Vienna, Österreichische Galerie).
Even in the naturalistic simplification of the view, the recession of the trees along the driveway lends a sense of depth to the overall picture. The focal point of the work is directed into the background, where the eye finds relief from the dense tangle of the branches.

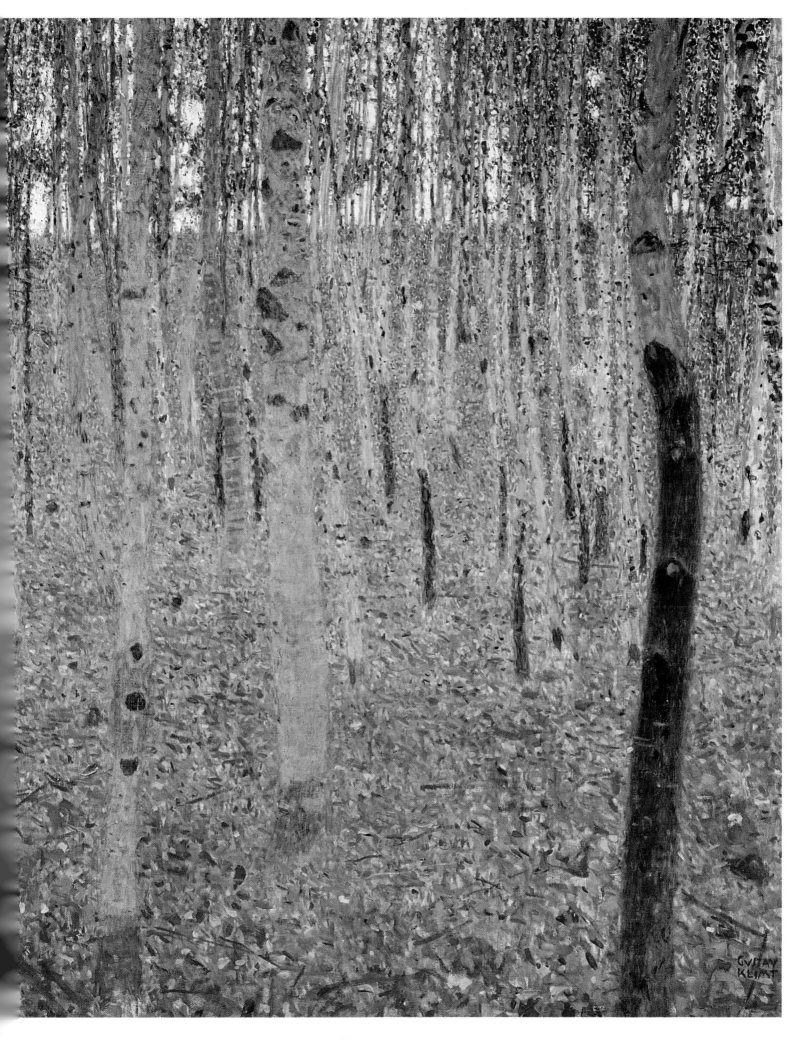

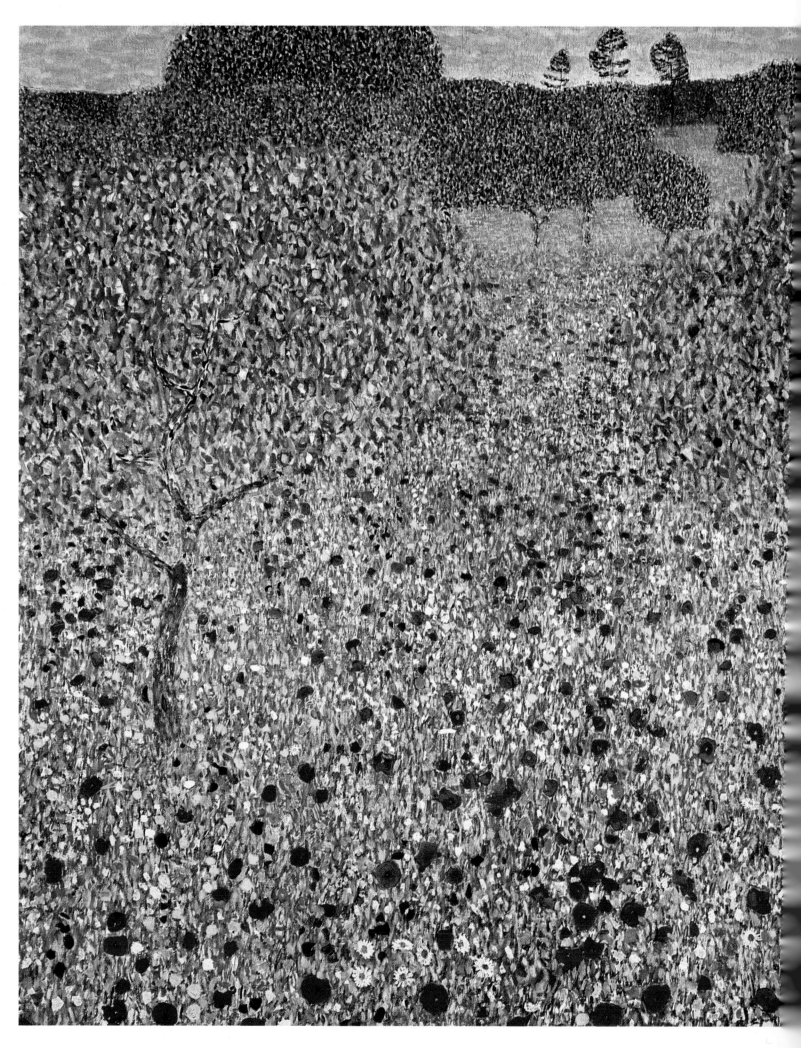

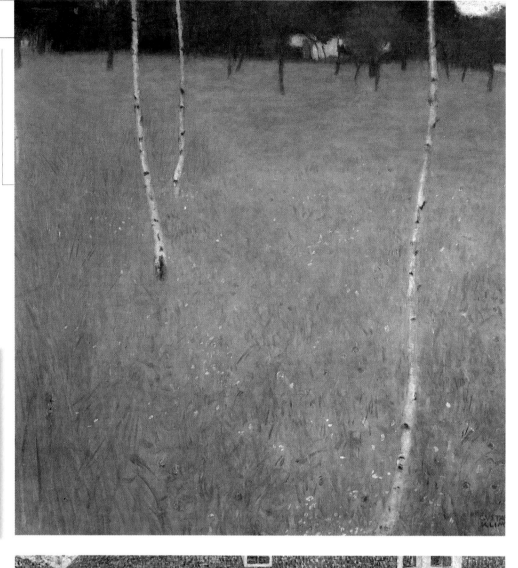

◆ FARMHOUSE
WITH BIRCHES
(1900, Vienna,
Österreichische
Galerie).
Framing the scene
with such a high
horizon emphasizes
the vastness of nature,
but a sense of void
and absence is evoked
by the few scattered
birch trees marking
off the composition,
with a bold spareness
reminiscent
of Japanese art.

◆ FIELD OF POPPIES
(1907, Vienna,
Österreichische Galerie).
The luxuriant carpet of
flowers, seemingly
blurred – as in Monet's
*Poppies* (1873, Paris,
Musée d'Orsay, above) –
appears to have neither
beginning nor end.

◆ SCHLOSS KAMMER
ON THE ATTERSEE III
(1910, Vienna,
Österreichische Galerie).
The luminous
*pointillisme* of this
picture recalls
the picture of the *Grande
Jatte* by Seurat
(1884, Chicago, Art
Institute, below).

# PORTRAITURE

K limt's portrait gallery is a hymn to female beauty. His few male portraits date to the 1890s, and there are no known self-portraits of the artist. So, what passes before our eyes is a procession of the most prominent society women of *fin de siècle* Vienna, who – immortalized by the most fashionable painter of the moment – opulently exhibit their social status.

● While Klimt's male portraits concentrate exclusively on the face, his female ones are prevalently based on the full figure scheme. Curiously, the faithful transcription of features is limited to faces and hands, which are nonetheless often altered to obtain expressive effects. The bodies dissolve in a profusion of geometric shapes and bright colors. It seems almost as though in all these representatives of the female sex Klimt were seeking the archetype of woman, her modern essence. Unlike Schiele and Kokoschka, who depict the crisis of the individual in contorted deformations, Klimt concentrates on the surface aspect of the women, whose expression he presents sometimes scornful, sometimes like an enchantress, sometimes proud.

● The play of fabrics, converted into precious two-dimensional decorations, reveals an absolute absence of volume which renders these figures even more ethereal. From the diaphonous pre-Raphaelite sensuality of his early portraits to the redundant chromatic palimpsest of his last, Klimt gives priority to ascendent, serpentining *silhouettes* that are at the same time reminiscent of Mannerism and Art Nouveau. In comparison to these spiralling outlines, the faces appear disproportionately small.

● The aesthetics of beauty, proclaimed in the theory and practice pursued by Klimt in his work, brings to the surface the content and character of the figures portrayed. If their femaleness is not immune from erotic overtones, as is evident in the repeated motif of the open almond shapes, the sumptuousness of their clothes and tapestry-like backgrounds is evidence of their high rank in society. No trace of attributes appears, no further narrative element; the identity of the sitter is entrusted entirely to decoration, which transcending ornament becomes itself psychological substance.

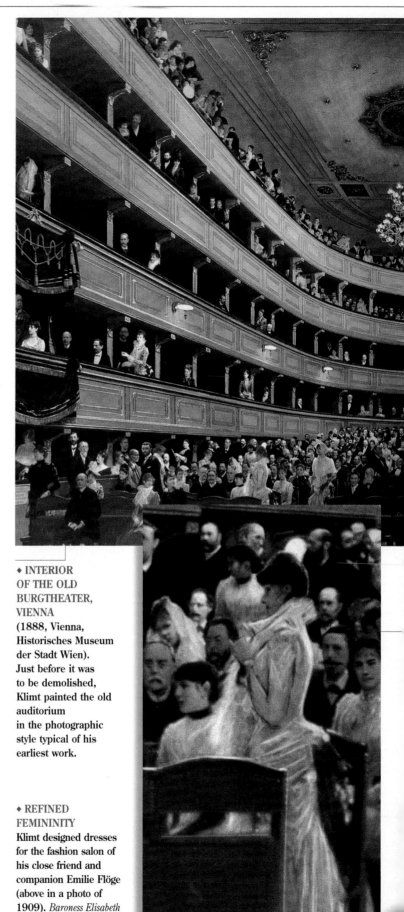

♦ INTERIOR OF THE OLD BURGTHEATER, VIENNA (1888, Vienna, Historisches Museum der Stadt Wien). Just before it was to be demolished, Klimt painted the old auditorium in the photographic style typical of his earliest work.

♦ REFINED FEMININITY Klimt designed dresses for the fashion salon of his close friend and companion Emilie Flöge (above in a photo of 1909). *Baroness Elisabeth Bachofen-Echt* (1914-16, in the oval at left) is set off by Oriental motifs in the background.

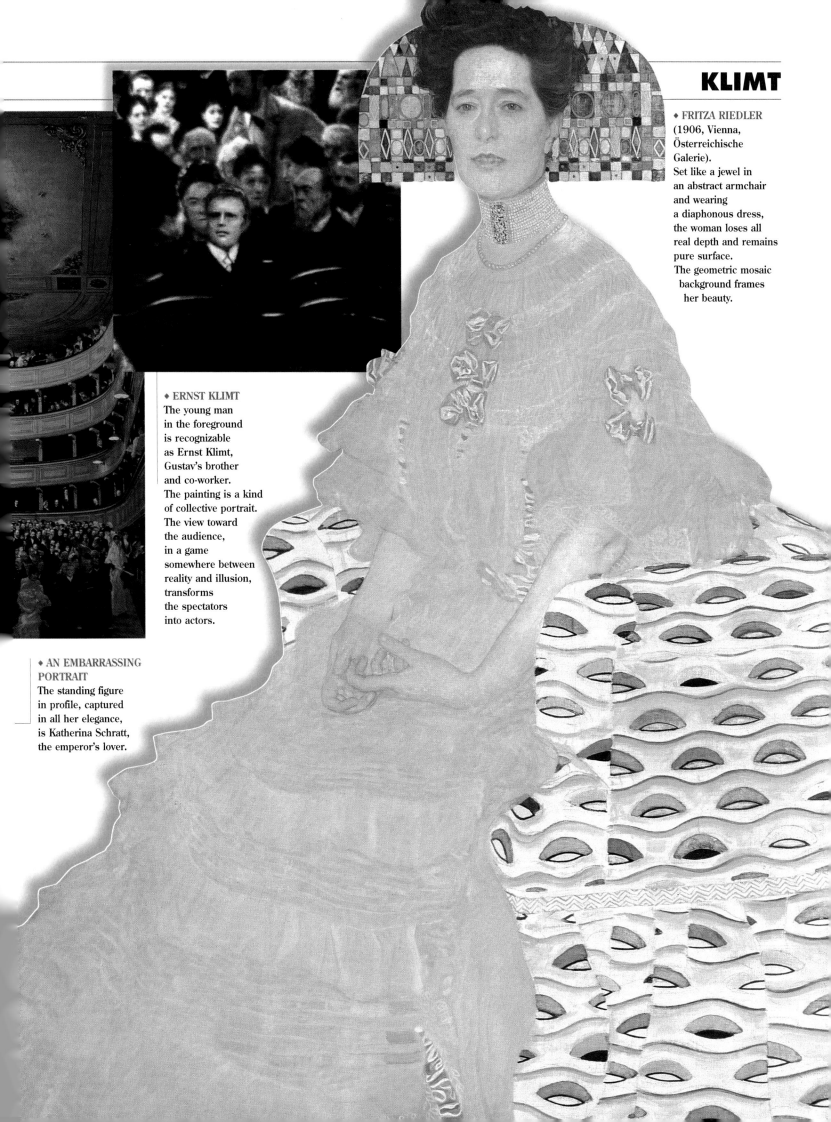

# KLIMT

◆ FRITZA RIEDLER
(1906, Vienna,
Österreichische
Galerie).
Set like a jewel in
an abstract armchair
and wearing
a diaphonous dress,
the woman loses all
real depth and remains
pure surface.
The geometric mosaic
background frames
her beauty.

◆ ERNST KLIMT
The young man
in the foreground
is recognizable
as Ernst Klimt,
Gustav's brother
and co-worker.
The painting is a kind
of collective portrait.
The view toward
the audience,
in a game
somewhere between
reality and illusion,
transforms
the spectators
into actors.

◆ AN EMBARRASSING
PORTRAIT
The standing figure
in profile, captured
in all her elegance,
is Katherina Schratt,
the emperor's lover.

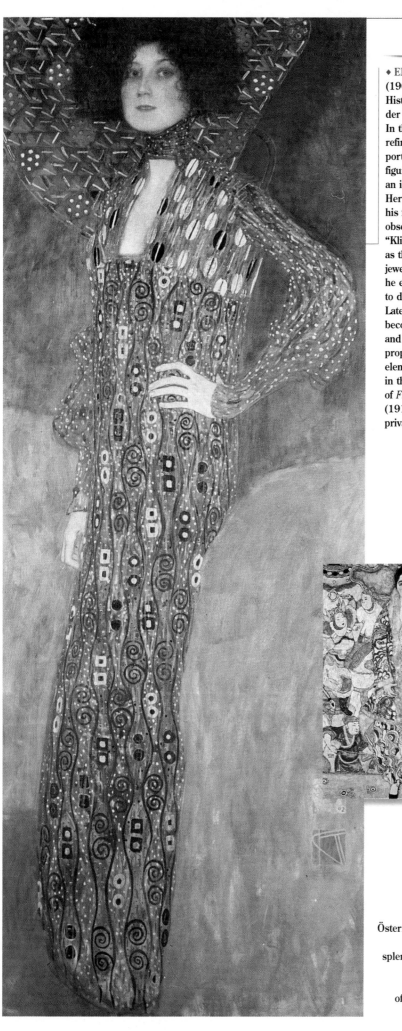

◆ EMILIE FLÖGE
(1902, Vienna,
Historisches Museum
der Stadt Wien).
In this, one of his most
refined society
portraits, the female
figure is stylized like
an icon. The writer
Hermann Bahr,
his fellow countryman,
observed astutely that
"Klimt paints women
as though they were
jewels." In this case
he even went so far as
to design her dress.
Later, his style would
become more florid
and chaotic, with a
propensity for Oriental
elements, as seen
in the portrait below
of *Frederike Maria Beer*
(1916, New York,
private collection).

◆ ADELE BLOCH-
BAUER I
(1907, Vienna,
Österreichische Galerie).
In the golden
splendor of this portrait
Klimt reached
the height
of his Byzantine-style
decorativism.

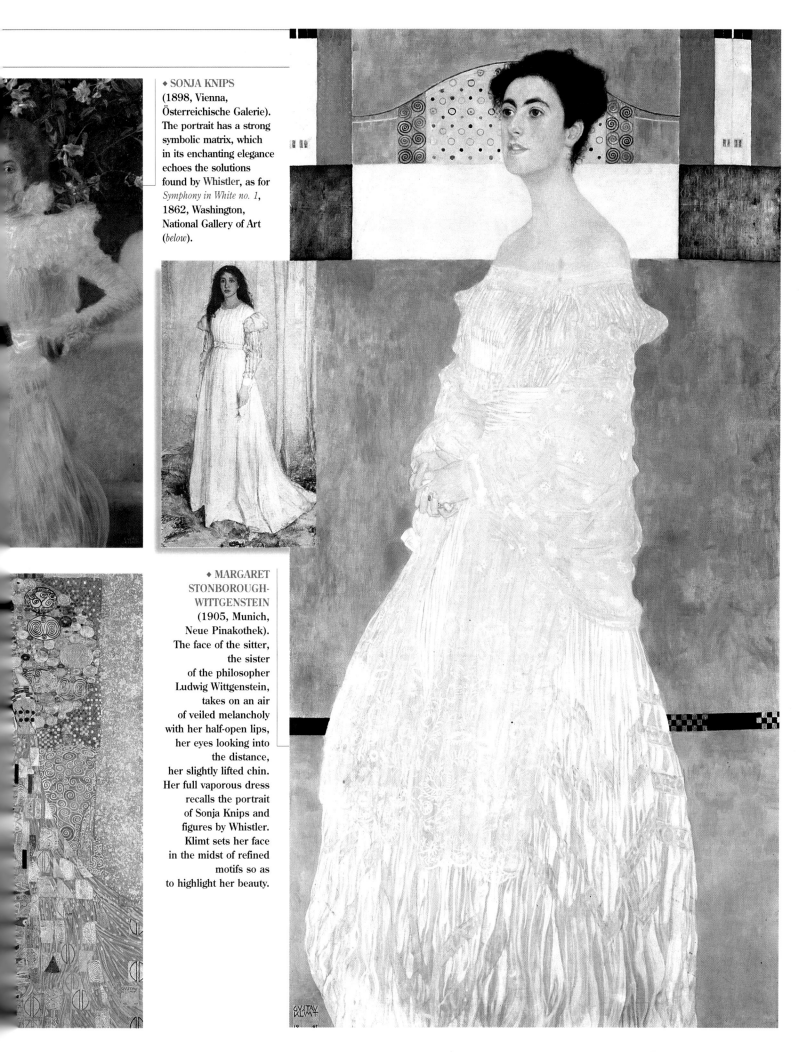

◆ SONJA KNIPS
(1898, Vienna,
Österreichische Galerie).
The portrait has a strong
symbolic matrix, which
in its enchanting elegance
echoes the solutions
found by Whistler, as for
*Symphony in White no. 1*,
1862, Washington,
National Gallery of Art
(*below*).

◆ MARGARET
STONBOROUGH-
WITTGENSTEIN
(1905, Munich,
Neue Pinakothek).
The face of the sitter,
the sister
of the philosopher
Ludwig Wittgenstein,
takes on an air
of veiled melancholy
with her half-open lips,
her eyes looking into
the distance,
her slightly lifted chin.
Her full vaporous dress
recalls the portrait
of Sonja Knips and
figures by Whistler.
Klimt sets her face
in the midst of refined
motifs so as
to highlight her beauty.

# KLIMT AND MUSIC

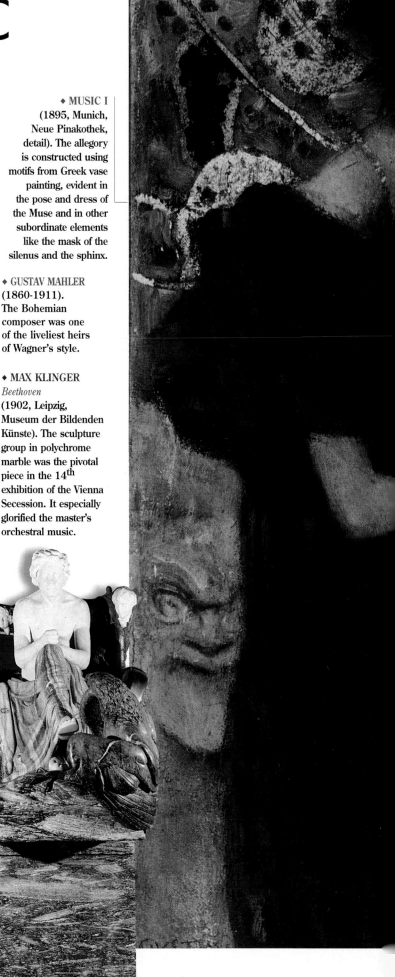

Vienna at the end of the nineteenth century was the privileged scene of the artistic activity of some of the greatest composers, from Brahms and Bruckner (who died in the 1890s) to the new generation of Richard Strauss, Gustav Mahler, and Arnold Schönberg. At his death in 1883, Wagner left behind a demanding legacy: in his concept of the total work of art, he placed music at the apex of human expression, as a model to which the other art forms had to aspire.

● If for Klimt the reference to music thus was obligatory, the painter preserved his originality by combining the musical form with the patterns of archaic Greek art (cf. *Music I*, 1895). In this process he showed that he was familiar with the philosophical theories of Nietzsche who in 1872, in his *The Birth of Tragedy from the Spirit of Music*, defined the fundamental tie between music and the Dionysian element of Greek culture.

● In 1898 Klimt painted two panels for the dining room of the Greek industrialist Dumba, a music lover who was particularly enamored of Schubert. This fact furnished his theme. The first panel is an allegory of music, while the second is an act of homage to the composer, which by association underlines Dumba's belonging to the top of the social pyramid.

● In 1902 the 14th Secession exhibition revolved around the sculpture group of Beethoven, the work of Max Klinger, for which the architect Hoffmann created a special pavilion. While Mahler inaugurated the exhibition with a new edition of Beethoven's *Ninth Symphony*, Klimt made the frieze which crowned the work and glorified the power of art in an unfolding allegory. In the cycle, a symbolic interpretation of the *Ninth Symphony*, the image of Music communicates an intense sacredness through a recourse to archaic Greek forms and offers itself as an instrument to free man from his earthly suffering. The frieze counterposes good and evil, and finds the solution in the coincidence of erotic and aesthetic elements.

◆ MUSIC I (1895, Munich, Neue Pinakothek, detail). The allegory is constructed using motifs from Greek vase painting, evident in the pose and dress of the Muse and in other subordinate elements like the mask of the silenus and the sphinx.

◆ GUSTAV MAHLER (1860-1911). The Bohemian composer was one of the liveliest heirs of Wagner's style.

◆ MAX KLINGER *Beethoven* (1902, Leipzig, Museum der Bildenden Künste). The sculpture group in polychrome marble was the pivotal piece in the 14th exhibition of the Vienna Secession. It especially glorified the master's orchestral music.

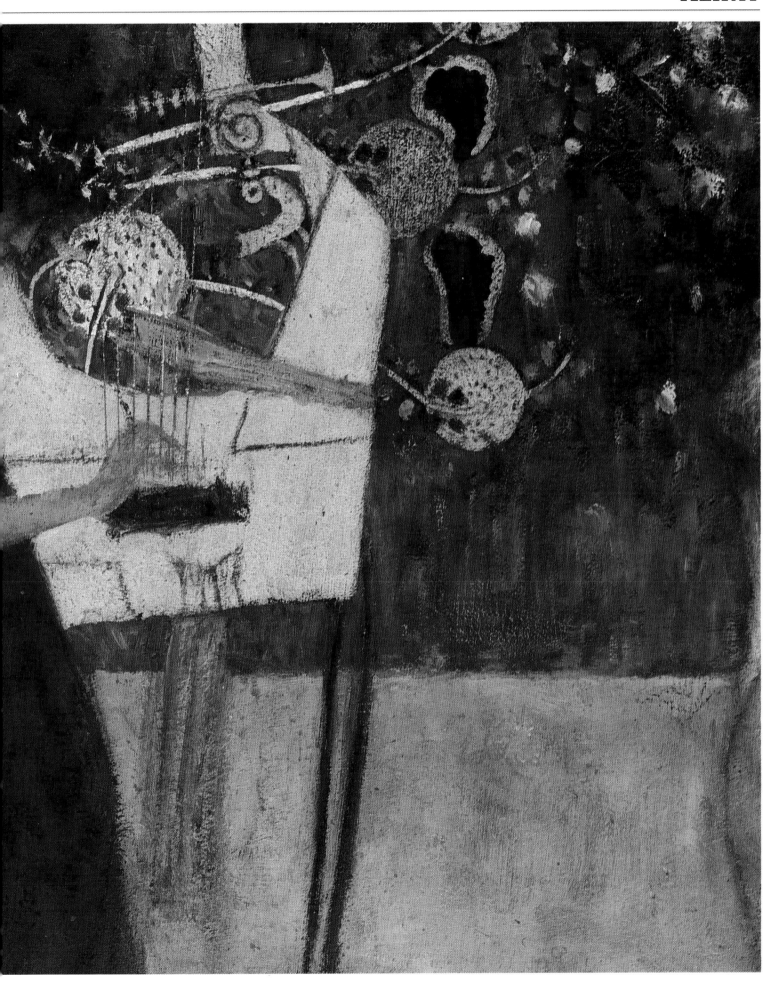

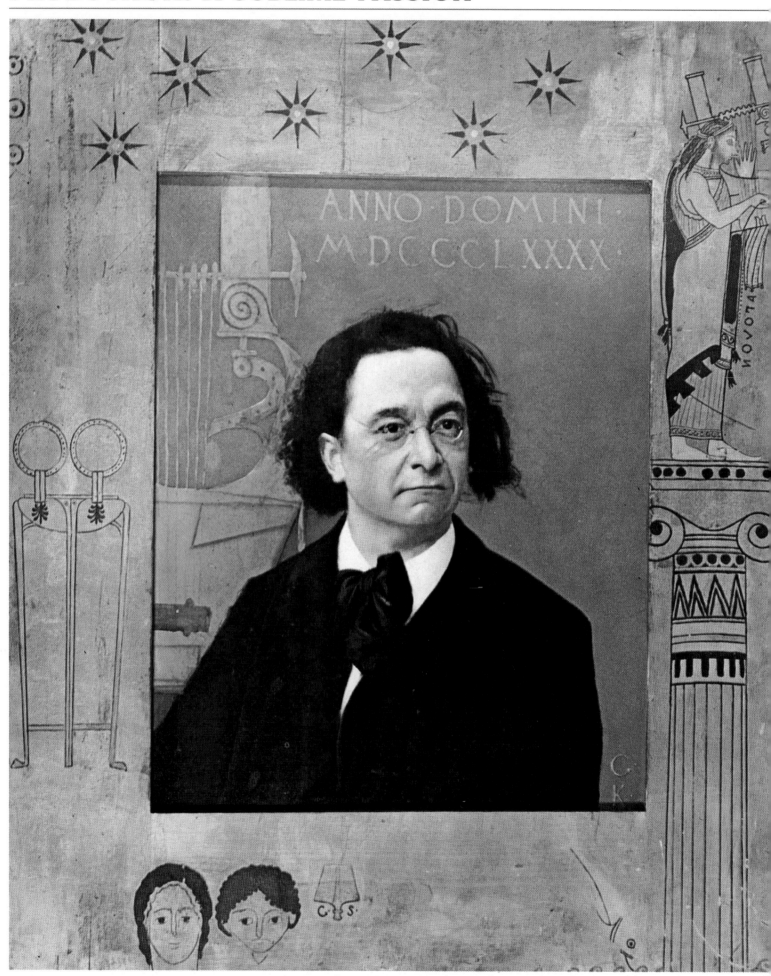

◆ SCHUBERT
AT THE PIANO
(1899, destroyed
in 1945).
The work, painted
for the industrialist
Dumba, although
portraying
the composer who died
in 1828, hints at
the middle class
splendor of late 19th
century Vienna. The
somewhat dreamy
atmosphere,
in which the figures
float in a moment of
refined idleness, still
belongs to
the symbolist phase
of Klimt's work.

◆ PORTRAIT
OF THE PIANIST
JOSEPH PEMBAUER
(1890, Innsbruck,
Tiroler Landesmuseum
Ferdinandeum).
The pianist is
portrayed with
the photographic
realism typical
of Klimt's early work.
The realism of
the painting is
answered dialectically
by the stylized
background and frame,
filled with flat forms
which, like the lyre and
the tripod, recall
archaic Greek themes.

◆ THE BEETHOVEN
FRIEZE
(detail of *Music*, 1902,
Vienna,
Österreichische
Galerie).
In his allegorical
description of
the liberating and
instinctual force of
music, Klimt made
Nietzsche and archaic
Greek culture part of
the current scene.

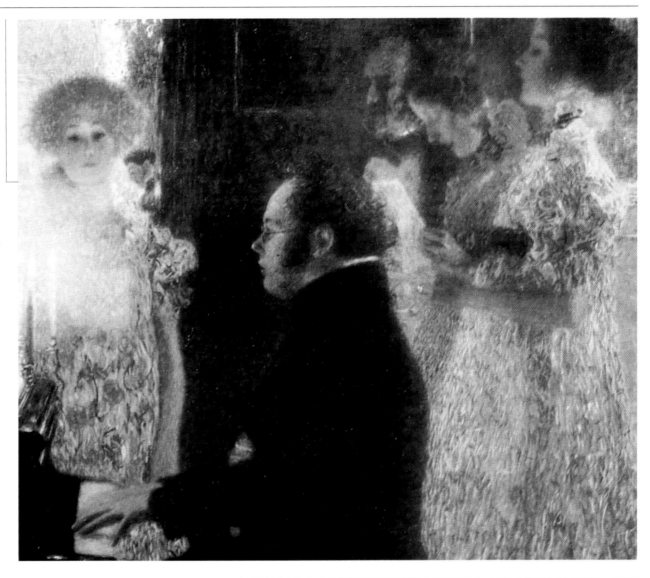

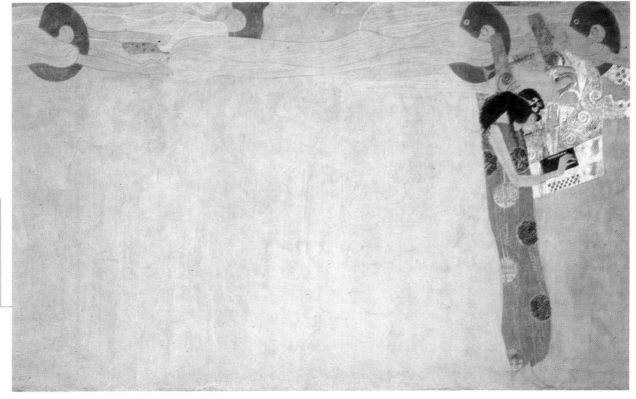

# ARCHITECTURAL DECORATION

From the 1860s on, Vienna was the site of a fervid activity of urban reconstruction, revolving around the creation of the Ringstrasse, the great traffic artery destined to become the symbol of an era. Among the artists engaged to give a new face to the capital of the Empire was Klimt, who had received his diploma from the School of Applied Arts as an architectural decorator.

● His earliest works in this area are the ceiling decorations for the staircases in the Burgtheater and the Kunsthistorisches Museum. The style of these history paintings is academic and literary, in harmony with the taste of the times. In the Burgtheater Klimt celebrated the history of theater and its connection with society, while for the Museum he embodied the history of art in female personifications.

● By now well on the road to success, in 1894 he received from the University of Vienna the commission for three paintings for the ceiling of its Great Hall. The theme of the cycle, reflecting Enlightenment values, was the triumph of light over the shadows of ignorance. Klimt was asked to provide allegories for three Faculties: Philosophy, Jurisprudence, and Medicine, on which he worked from 1897 to 1907. By then he had already adhered to the Secessionist Movement and was deeply committed to its project of renewal of the arts. His interpretation of the theme caused a sensation with the public and the authorities, who in the end decided not to install the paintings in their intended place.

● This episode marked the definitive break between Klimt and official culture and explains his turn towards private patronage. In 1905 he was asked to prepare the working designs for mosaics for the dining room of Palais Stoclet, built in Brussels by Hoffmann. Faithful to the concept of the total work of art, Klimt once again merged decoration with architecture.

◆ THE THEATER AT TAORMINA (1886-88, Vienna, Burgtheater, left staircase). In these decorations Klimt celebrates the role of theater in society.

◆ JOSEF HOFFMANN *Palais Stoclet* (1904-11, Brussels). With its studied but sober geometrical shapes, the building is a clear example of Secessionist architecture.

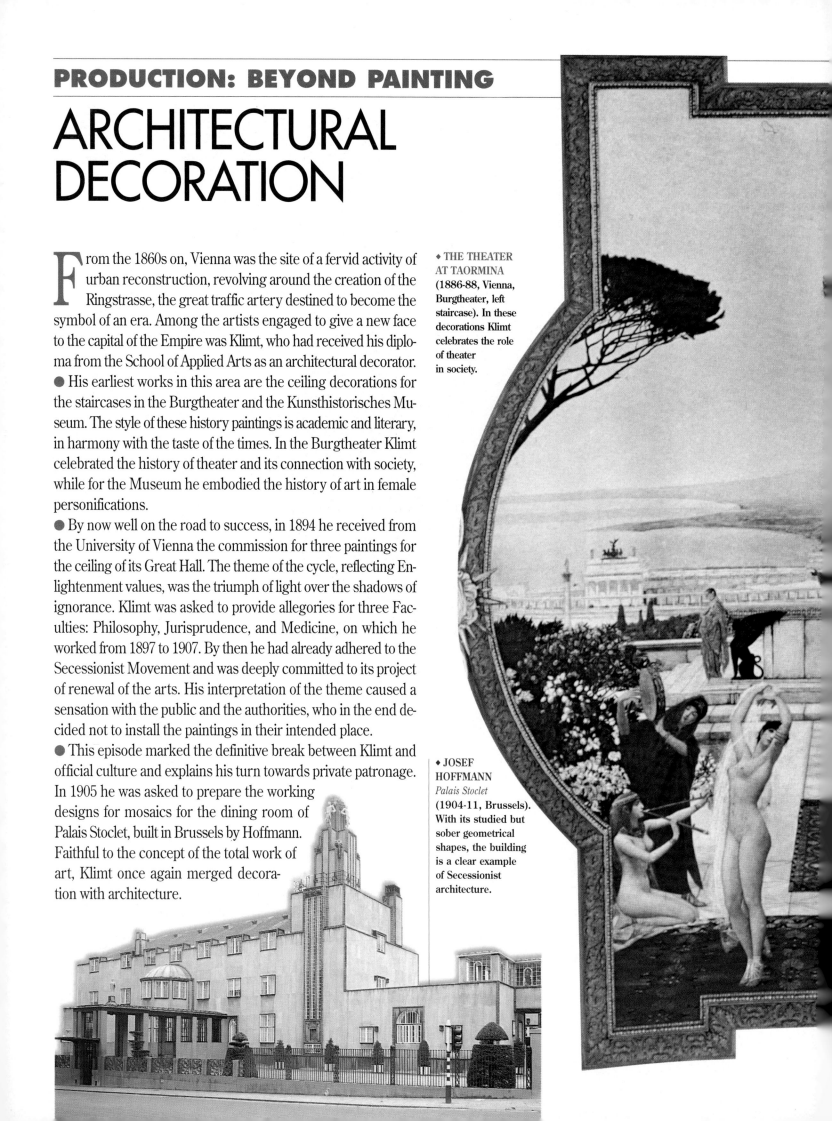

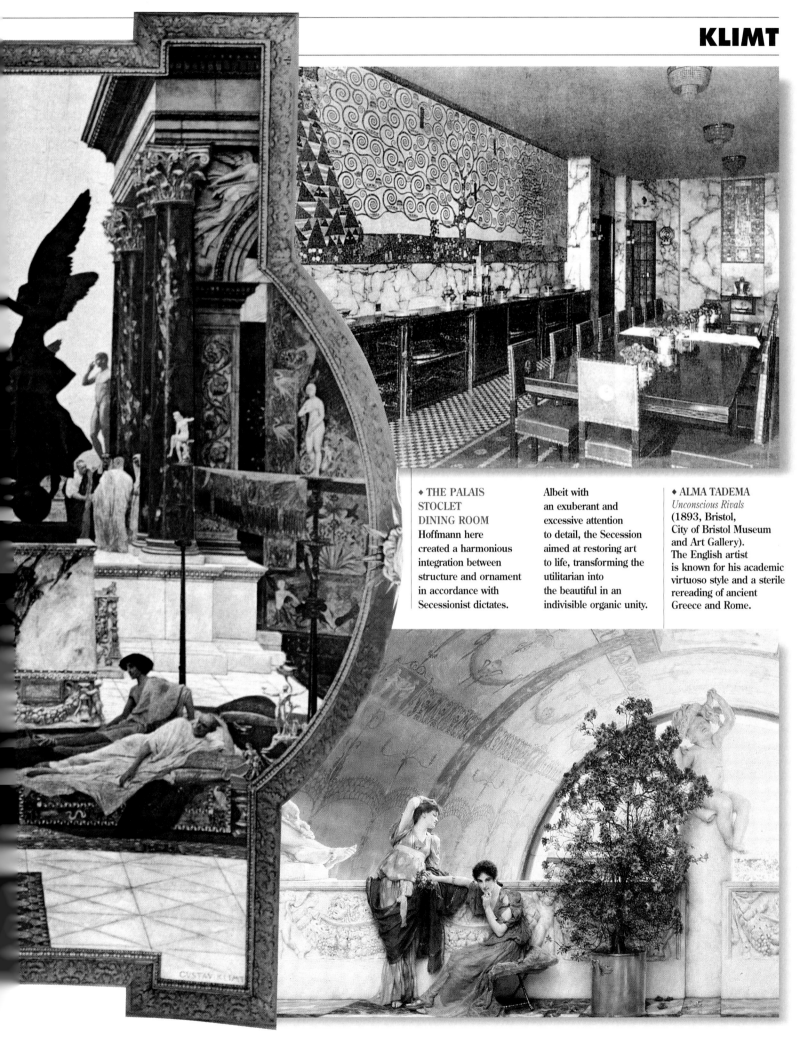

◆ THE PALAIS
STOCLET
DINING ROOM
Hoffmann here
created a harmonious
integration between
structure and ornament
in accordance with
Secessionist dictates.

Albeit with
an exuberant and
excessive attention
to detail, the Secession
aimed at restoring art
to life, transforming the
utilitarian into
the beautiful in an
indivisible organic unity.

◆ ALMA TADEMA
*Unconscious Rivals*
(1893, Bristol,
City of Bristol Museum
and Art Gallery).
The English artist
is known for his academic
virtuoso style and a sterile
rereading of ancient
Greece and Rome.

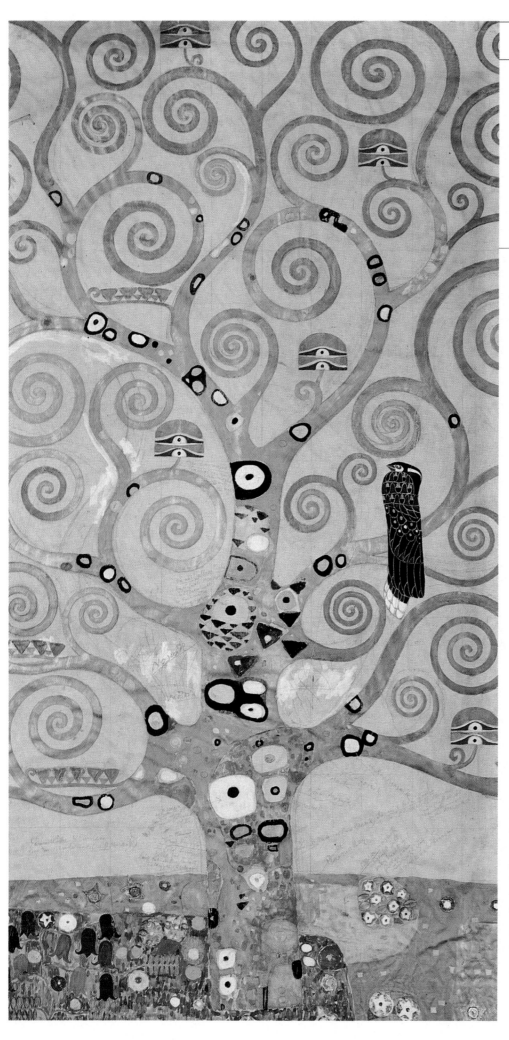

◆ THE TREE OF LIFE
(CENTRAL PANEL
OF THE CARTOON
FOR THE STOCLET
FRIEZE)
(1905-09, Vienna,
Österreichische Galerie,
detail).
The mosaic, made
to Klimt's design by
the workshops of
the Wiener Werkstätten,
presents a symbolic Tree
of Life which invades
the walls with its
stylized, elegant scroll
motif. Among the
arabesque curls,
citations of Egyptian
motifs like the ujat-eye
and the owl heighten
the symbolic significance
of the subject.

◆ OTTO WAGNER
*Underground transport
station*
(1894-97, Vienna).
The Secessionist
architects succeeded
in giving a new face to
the capital, thanks to
the elegant and
strongly decorative
taste with which
they transfigured even
utilitarian structures.

◆ MEDICINE
(1898-1900, Vienna,
private collection).
*Medicine* (above, overall
view; right, detail) was
shown at the 10th
Secessionist exhibition,
exacerbating
the controversy which
arose with
the presentation of
*Philosophy*. Instead of
the expected comforting
search for truth through
science heralded by
Positivism, Klimt
described in theatrical
and pessimistic tones an
enigmatic, fluctuating
nature, against which
man is powerless.
The protagonist is a
suffering, hopeless
humanity which was
incompatible with
the rationalism
professed by the
university world. The
original painting was
destroyed in 1945.

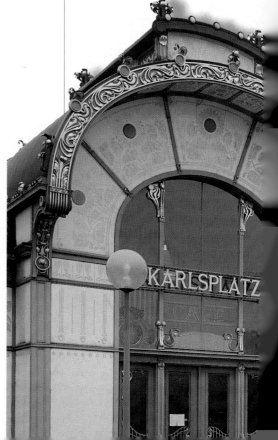

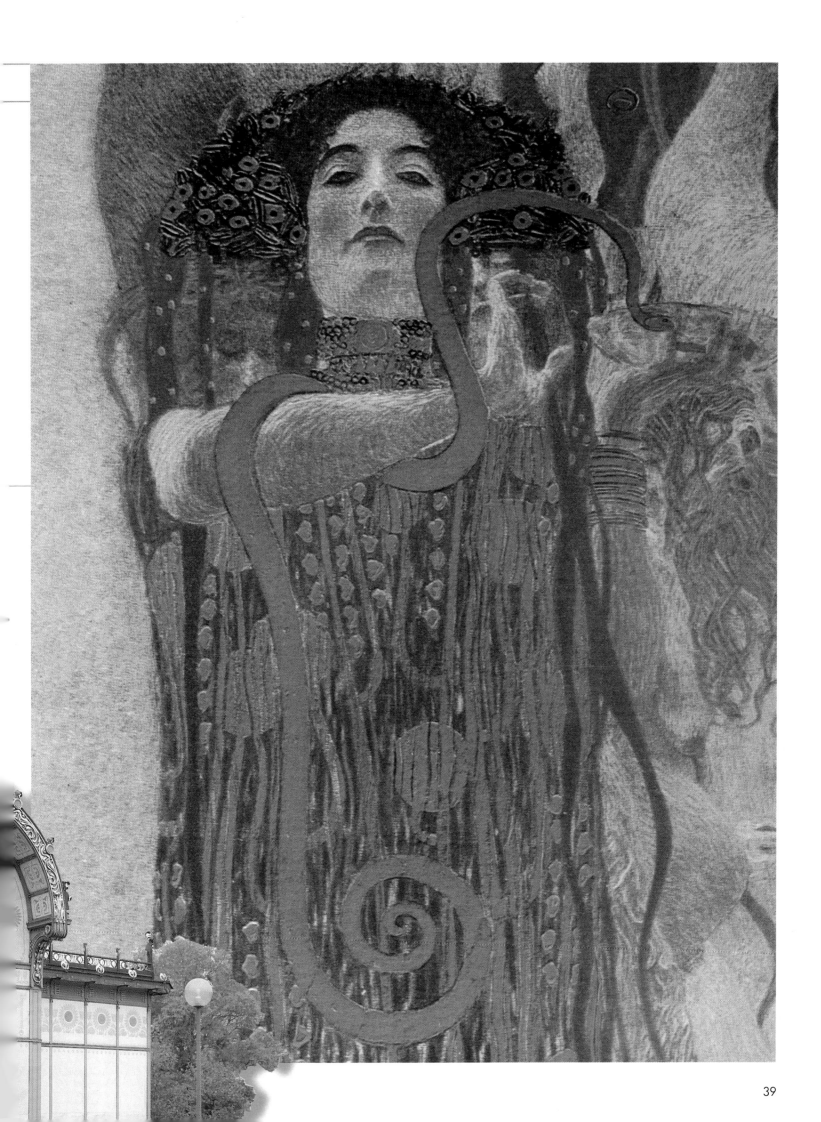

# FIN DE SIÈCLE VIENNA

"The proving ground for the destruction of the world": with these words Karl Kraus summed up the fragility and contradictions which marked Vienna, capital of the Habsburg empire, between the end of the nineteenth century and the First World War. The city was the center of a vast, multi-ethnic dominion which stretched from Prague to Budapest and Sarajevo. But this gilded world was in a progressive state of decline. The court itself generated discontent and dissension in the heart of the empire because of its myopic, conservative outlook.

● Vienna was the cradle of a cultural revolution destined to overturn the traditional concept of man, bringing to light its

tem, and Mahler composed his fervent appeal *The Song of the Earth*, while Wittgenstein was asking questions about the relationship between logic and linguistics.

But the most tumultuous wave was provoked by psychoanalysis. *The Interpretation of Dreams* appeared in 1900, *Introduction to Psychoanalysis* in 1916. Freud invalidated the recent positivist enthusiasm by demonstrating that human actions have unconscious causes which do not answer to rationalist criteria. With his theory of relativity, Einstein heightened the sense of loss and human frailty in the face of a reality which was revealed to be unknown and unstable.

● Despite its apparently frenetic cultural activity, in Vienna the

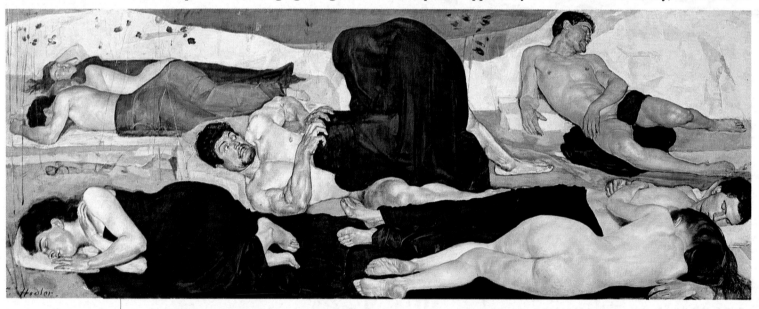

♦ FERDINAND HODLER *Night* (1889-90. Bern, Kunstmuseum). The exhausted expressions of the faces and the bodies languidly stretched out reflect an uncertainty of values and a state of tension echoed by the cool, shrill palette.

contradictions and calling its certainties into question. Klimt immortalized the rites and magnificence of a middle class dancing Strauss's latest waltz, while Karl Kraus attacked the hypocrisy and falseness of that world. The works of Arthur Schnitzler and Musil described with bitterness and psychological introspection the crisis of the individual which Kokoschka and Schiele were investigating in painting. Schönberg revolutionized the canons of musical harmony with his twelve-note sys-

sun was setting on an era. The sheer vastness of the empire made it impossible to control, while, although still latent, the first signs of economic hardship were being felt. The delicate balance of diplomatic relationships was cracking, to the point of the rupture which resulted in the First World War. The Austria of the Habsburgs left the world stage with its last swan song offered to humanity before disappearing under the impact of the war of 1914-18.

♦ RINGSTRASSE (1888, Vienna). Built on the site of the old city walls, in a redefinition of the urban plan, the Ringstrasse (above) is the place where the bourgeoisie idly promenaded toward the theater, city hall, and parliament buildings.

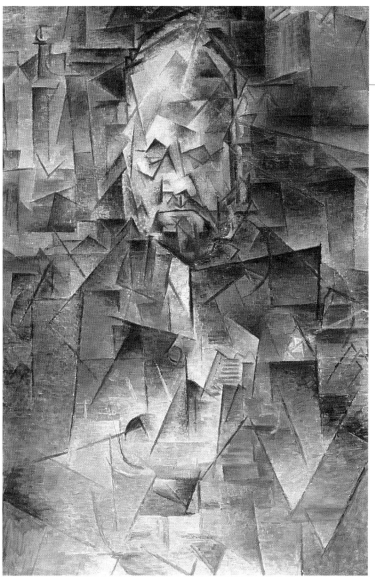

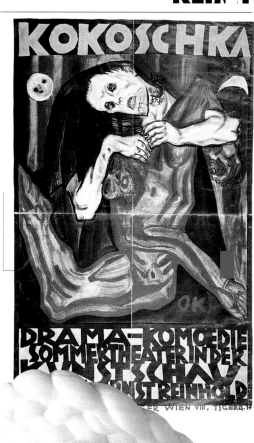

♦ PABLO PICASSO
*Ambroise Vollard*
(1909-10, Moscow,
Pushkin Museum).
Like the other fields
of knowledge, painting
too participated in
the redefinition
of reality, going beyond
the limits of a simple
reproduction of life.

♦ OSCAR KOKOSCHKA
*Pietà*
(1908, Poster for
the open-air theater of
the Vienna Kunstschau).
The individual's sense
of being lost, typical
of the time, is expressed
in the deformation
of the forms.

♦ SISSI
Elisabeth
of Bavaria,
the wife
of Emperor
Franz Joseph,
was to
the popular
mind
the symbol of
the strength of
the empire.

♦ OSCAR
KOKOSCHKA
*Adolfo Loos*
(1909, Berlin,
National Galerie
SMPK).
The tormented line
and dark colors reflect
the painter's pessimism
and the decline
of an era. In his book
*Ornament and Crime*
(1908), the architect
Loos condemned
the decorative
exuberance
of the Secessionists.

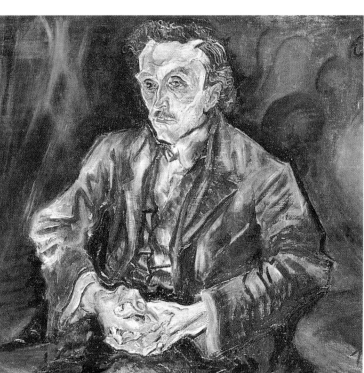

# EROTIC TORMENT AND CHROMATIC HEDONISM

Klimt's death coincides with the epilogue of the First World War, which after sweeping away every remnant of pleasure led to a brusque change of direction toward a raw realism which eschewed every form of decorativism or technical virtuosity. His art is inconceivable outside his specific Austrian context.

● Nonetheless, a superficial return to Klimt's preciousness, in painting or in objects for everyday use, can be found in Italy among the painter-aesthetes favored by d'Annunzio, Galileo Chini above all. Ubaldo Oppi merits a place by himself: during a stay in Vienna he took courses from Klimt and was enlightened by the splendor of his teacher's painting to the point of basing his own realism, realized in glacial, analytical tones, on the preciousness of Klimt's work.

● Klimt's true legacy was assumed by Kokoschka and Schiele, the new generation of Austrian painters. Both of them inhabited the contradictory world which Klimt portrayed and discerned its crisis. The stylized forms become angular, tormented. The existential drama and uncertainty of values expressed by the figures explode across the surface in subdued tones and deformed physiognomy. Even love, which Klimt had treated in a positive manner, expressing a provocative eroticism which never went to extremes, now became violence, depravation. As the dazzling lights of the Habsburg empire were going out, the humanity painted by Kokoschka and Schiele finds itself alone and adrift, disfigured by pain.

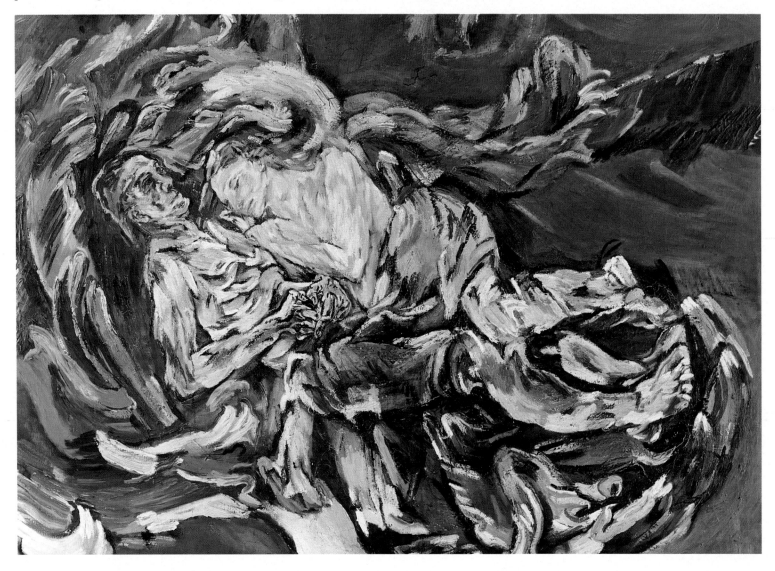

♦ OSCAR KOKOSCHKA
*The Bride in the Wind*
(1914, Basel,
Kunstmuseum).
The artist reveals his
intolerance for a world
that was disintegrating
behind a facade as
precious as it was
fragile. He paints
in dark tones
a desperate humanity
that even in the line
seems to dissolve and
lose consistency,
as though deprived
of identity. Kokoschka's
disquieting images
render an apocalyptic
sense of a universe
on the wane.

♦ PIERRE BONNARD
*The Dressing-Gown*
(1892, Paris, Musée
National des Beaux
Arts). The French artist
participates in the same
decorative climate of *Art
Nouveau* to which Klimt
also adheres and creates
his volumes using
a meticulously described
ornamental fabric.

♦ RICHARD GERSTL
*Arnold Schönberg*
(Vienna,
Österreichische Galerie).
Among Klimt's heirs
who describe society's
contradictions,
Gerstl depicts
the restless spirit
of the inventor
of the twelve-note scale
in a middle class interior.

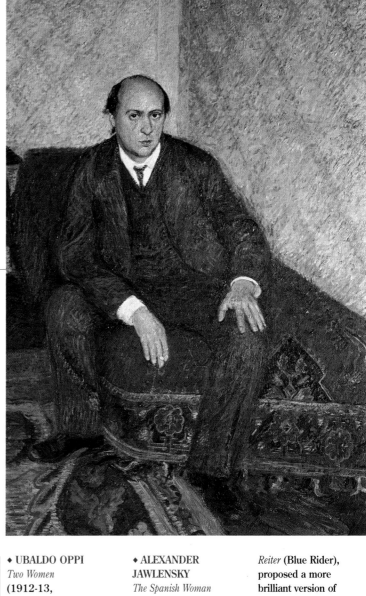

♦ UBALDO OPPI
*Two Women*
(1912-13,
private collection).
Oppi borrows from
Klimt his decorativism,
flat stylization, bright
colors, mosaic
construction,
and even his obsessive
attention to detail.
He adopts Klimt's
aristocracy
of form and color
for his portraits of
members of the upper
middle class.
This nostalgic, refined
approach to the human
figure dominates also
his realistic style in
the 1920s, where it
constitutes the element
distinguishing him
from his German
colleagues, proponents
of the *Neue Sachlichkeit*
(New Objectivity).

♦ ALEXANDER
JAWLENSKY
*The Spanish Woman*
(1913, Munich,
Lenbachhaus).
The Russian artist,
who with Kandinsky
participated in the
experience of the *Blaue
Reiter* (Blue Rider),
proposed a more
brilliant version of
Klimt's preciousness.
The expressive freedom
he accorded to color
is evident here in the
bright patches he uses
to structure the face.

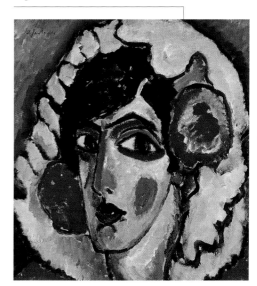

# THE ARTISTIC JOURNEY

For an overall vision of Klimt's production, we have compiled a chronological summary of his principal works

### ◆ INTERIOR OF THE OLD BURGTHEATER, VIENNA (1888)

Commissioned to celebrate the old Burgtheater which was about to be rebuilt, this painting provides an authentic witness for the presence of numerous identifiable faces, making the picture a group portrait. The photographic realism of the painting, for which the emperor personally awarded Klimt a prize, reveals the artist's versatile talent.

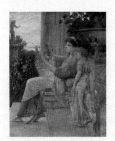

### ◆ SAPPHO (1888-90)

Still in a sketchy state, the canvas merges the influence of the pre-Raphaelites with the literary, dreamy symbolism of Moreau. Built around right angles, it is permeated by an allegorical mythology already seen in the works for the Burgtheater. The description of details is consonant with the historicism which influenced also the art of the period and celebrates beauty in a refined archaizing atmosphere.

### ◆ PORTRAIT OF THE PIANIST JOSEPH PEMBAUER (1890)

The photographic realism of the face sets up a subtle tension with the symbolism of the stylized elements. The stylistic dilemma between historicism and symbolism, which tormented Klimt in this period, is here resolved through the mediation of archaic forms which attribute to music, represented by the instruments, an absolute and eternal value, and this high praise is reflected onto the pianist.

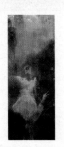

### ◆ LOVE (1895)

The painting reveals its symbolist matrix in the evanescent and rarefied figures. The work is part of the series of publications entitled *Allegories and Emblems*, whose aim was to give visual form to the most meaningful moments of human life and their psychological implications using strongly metaphorical images. In the heads at the top of the painting, Klimt represents the cycle of existence as an admonition of the fleeting nature of beauty and love.

### ◆ MUSIC II (1898)

The protagonist of this work, destroyed by fire at Schloss Immendorf in 1945, is music, represented by the lyre. And yet, the image – which simulates Greek vase painting – is dominated by other figures: the sphinx (alluding to artistic freedom), the silenus mask, the lion's tooth (metaphor for the spread of new ideas), and the *femme fatale* face of the woman.

### ◆ SONJA KNIPS (1898)

Echoing the symbolism of the Belgian Khnopff, Klimt portrays a woman of the Viennese élite who was an active patron, along with her husband, of the Wiener Werkstätte. The carefully modeled face contrasts with the soft inconsistency of her dress. In the diagonal composition, the evanescence of the chair, the red patch of color of the sketchbook, and the head surrounded by flowers prefigure the scheme used in the portraits of his "golden period."

### ◆ PALLAS ATHENE (1898)

The painting's effect is heightened by the frame made for it by Georg Klimt, Gustav's brother. Following the example of the Munich Secession, the Greek goddess was adopted as a protectress by the Viennese Secession. Athene is portrayed in front of a frieze borrowed from a 6th century B.C. Attic black-figure vase. Her red hair escapes from her helmet to underline the goddess's femininity despite her armor.

### ◆ NUDA VERITAS (1899)

On the upper edge of the picture a line from Schiller is quoted which indicates that pleasing only a few is a sign of quality. The purpose of the quotation was to spur the Viennese Secessionists to action. An engraving of the painting was made for the magazine *Ver Sacrum*. The mirror held up by Truth is a modern invitation to "Know thyself," while the flowers are a symbol of regeneration.

### ◆ AFTER THE RAIN (1899)

Painted at St Agatha in upper Austria, the painting represents a pleasant exception in Klimt's gallery, for the presence of animals in the picture. The long format and curious photographic framing indicate a Japanese influence. The rainy veil enveloping the scene and the ornamental interpretation of each element echo the evanescence of Whistler's landscapes.

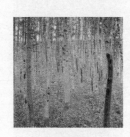

### ◆ THE BEECH FOREST I (1902)

The series of beech forests corresponds to the paintings of lake subjects made in the same years. Repeated elements are the high horizon, the square format, the close-up view. The rhythmic sequence of the trees, far from being heavy on the eye, plays with the liveliness of the colors and the slenderness of the trunks to draw the spectator deep into the landscape.

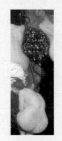

### ◆ GOLDFISH (1901-02)

The painting, shown at the 13th exhibition of the Secession and in Dresden in 1904, aroused such an outcry that Klimt resentfully thought of entitling it *To My Critics*. The work, with symbolist overtones, is dominated by the nude back, a quotation from Rodin. The inviting aspect and soft Jugendstil lines of the mermaids intentionally immerse the work in an elegantly erotic dimension.

### ◆ HOPE I (1903)

The unusual subject and its formal rendering have aroused perplexity, to the point that in order to exhibit the work recourse had to be made to a religious interpretation. The theme of the pregnant woman had already appeared in one of the figures in *Medicine* and in the *Beethoven Frieze*. In 1907-08 Klimt painted a second version, this time wearing a dress with a stylized jewel-like geometric pattern.

### ◆ THE THREE AGES OF WOMAN (1905)

The painting won the prize at the International Art Exhibition in Rome in 1911 and the following year was purchased by the Galleria Nazionale d'Arte Moderna. The canvas unites a geometrical decorativism with an unexpected psychological introspection in the expression of the three figures; the old woman's dramatic premonition of the end, the protective tenderness of the young woman, and the secure and relaxed abandon of the child.

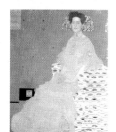

### ◆ FRITZA RIEDLER (1906)

This portrait is the one most often shown in Klimt exhibitions. It represents the most splendid example of his "geometric phase," with its diagonal composition and almost inconsistent dress. The suggestive contrast between the rhythmic repetition of decorative symbols and the plastic modeling of the face and hands gives the measure of the dialectic between figurativism and abstraction typical of this phase of Klimt's work.

### ◆ WATER SNAKES I (1904-07)

The painting was created using different techniques, from water color to tempera, to the final application of gold leaf to the parchment. The composition repeats the elongated forms in slender silhouettes typical of the Jugendstil, but the protagonist is the redundant decoration of his "golden period," which plays on the abstract but allusive motifs of the embrace and the open almond shapes.

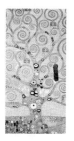

### ◆ THE TREE OF LIFE (CENTRAL PANEL OF THE CARTOON FOR THE STOCLET FRIEZE, 1905-09)

The symbolism of the tree of life, which spreads across the walls with large scrolling tendrils, echoes the solution found by Lorenzo Lotto for his frescoes in the Suardi chapel at Trescore. Diverse influences come together in the frieze, from Byzantine mosaics to Japanese prints. But the dominant element is Egyptian culture, in the pose of the figures and the repetition of decorative motifs.

### ◆ THE PARK (1909-10)

This is one of the works in which Klimt comes closest to abstraction, without however taking the final leap. The teeming colors and tiny shapes of the vegetation imbue the picture with a sense of vitality which evokes the natural life cycle. The view is very close-up, as in Klimt's other landscape paintings. The brushwork recalls the virtuoso execution found in mosaics.

### ◆ THE BLACK HAT (1910)

For its "unfinished" style, unusual in Klimt, the synthetic image devoid of any decorative support, and the dark tones, the figure seems to echo those by Toulouse-Lautrec, whom the artist had discovered the preceding year in Paris. The model's red hair and lopsided hat have already been seen in the *Lady with Hat and Feather Boa* of 1909.

### ◆ DEATH AND LIFE (1906-11)

The pronounced caesura cutting the composition in two corresponds to symbolic motifs: the disquieting, dark shadow of death looms over the tangle of human figures, where the color lights up with decorative vivacity. The ascending structure represents the salient moment of life: from friendship to love, to motherhood. The knotty physique of the man would inspire Schiele's nudes.

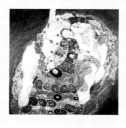

### ◆ THE VIRGIN (1912-13)

From his usual pictures of the aristocracy, Klimt now moves toward erotic allegories like *Death and Life*. The tangle of seven women has lost all trace of realism, as is evident by the practically skeletal nude on the left, and is reabsorbed by the decorative texture of the fabrics. The association betwen beauty and such unnatural poses alludes to the fleeting nature of life, a reflection of the decadence of contemporary society.

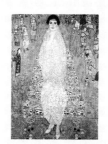

### ◆ BARONESS ELISABETH BACHOFEN-ECHT (1914-16)

An Oriental note dominates in the figures framing the Baroness. The pyramidal structure of the subject is accompanied by an abstract, tightly closed syntax typical of Klimt's last works. With the end of his "golden phase" in 1909 and overcoming the crisis that followed, the artist rejected Greek and Egyptian models to concentrate now on a festive liveliness of color, close to the work of Matisse.

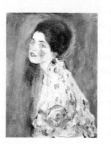

### ◆ PORTRAIT OF A LADY (1916-17)

Painted in a rapid and lively style, the portrait possesses a serenity unusual in Klimt's work. Here he alters the realism of the face with patches of bright color and thus moves into the expressionist vein, approaching especially images by Jawlensky. Nontheless, he opposes to the grainy, violent deformation practiced by his colleagues his habitual taste for precious ornamentation.

### ◆ FRIEDERIKE MARIA BEER (1916)

The sitter, the daughter of the owner of the Kaiserbar, also had her portrait painted by Egon Schiele. Klimt portrays her wearing a dress made by the Wiener Werkstätte. To heighten the effect of magnificence he repeats the Oriental elements from the portrait of *Baroness Elisabeth Bachofen-Echt*, borrowed from a Korean vase. The red, white, and black flag at the top evokes the Austrian flag and alludes to the outbreak of World War I.

### ◆ THE DANCER (1916-18)

The portrait was painted on a canvas that had already been used previously. Alongside the Oriental elements typical of this phase, Klimt included also flowers, a small table, and a rug with a geometric motif. These objects, defying the laws of perspective and in some ways close to Cubism, introduce a narrative note into the work. Just as unusual in a portrait by Klimt is the erotic accent given by the bare breast.

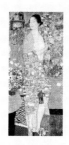

### ◆ ADAM AND EVE (1918)

The painting, left unfinished, takes on symbolic value for its Biblical subject and the treatment of Eve's face, with her bent head and sweet but enigmatic smile. The lower part, with the decorativism of the flowers and background, is typical of Klimt's work, while the upper section, where the figures dominate a monochrome ground, reveals a synthesis of tormented lines closer by now to the style of Schiele.

### ◆ THE BRIDE

This unfinished work is part of the collection of Emilie Flöge. It is Klimt's last great allegory and forms a *unicum* with *The Virgin*. As though the artist were summing things up, here reappear earlier motifs: the bare back is taken from *Goldfish*, the face of the bride derives from *Death and Life*. The figure on the right, nude beneath a light veil decorated with phallic symbols, is a presage of her imminent initiation.

# TO KNOW MORE

The following pages contain: some documents useful for understanding different aspects of Klimt's life and work; the fundamental stages in the life of the artist; technical data and the location of the principal works found in this volume; an essential bibliography

## DOCUMENTS AND TESTIMONIES

## A modern poet

"I have never painted a self-portrait. I am less interested in myself as a subject for painting than I am in other people, above all women. But other subjects interest me even more."

[G. Klimt]

"The greatest artist who ever walked the face of the earth."

[O. Wagner]

"Klimt's ornament is a metaphor for primeval matter constantly, endlessly mutating, that develops, whirls, spirals, winds, an impetuous turbine which can take any form, flashes of lightning and darting snakes' tongues, clinging vine tendrils, tangled chains, dripping veils, spread nets."

[L. Hevesi]

"Depth becomes flat for him, the surface opens onto sudden depths, eternity is detected in the smallest things, but even so – it seems – he is only playing, we don't know... if we are in the splendor of heaven or still at the theater. We are still in a tight circle measuring from here to there; this is the fatherland of our Austrian art."

[H. Bahr]

"Gustav Klimt, you are at the same time a visionary painter and a modern philosopher, but above all a modern poet. When you paint, it is as though, like in a fairy tale, you transformed yourself into the most modern of men, something that, in real life, maybe you are not."

[P. Altenberg]

"What is especially admirable in Klimt is the freedom with which he treats everything. He is a person who goes straight along his own path and at the same time is so typically Viennese with his grace and tenderness."

[F. Hodler 1905]

"Here they've overdone it! A burning rage invades anyone who still has a grain of modesty. What can be said of painted pornography like this? To describe it would be to pay it too much honor. Filthiness like this belongs in a cave where pagan orgies are held, certainly not in rooms open to the public."

[Anonymous]

## A Facade of Pure Splendor

"Klimt knew how to capture in depth the snobbism, arrogance, and haughtiness of his subjects much better than Schiele was able to do with his. For neither of them, however, was the human being of any interest whatever, men being for them simple figurines, a complex, subtle bundle of nerves for Klimt, a sad, dark crowd for Schiele."

[A. Faistauer]

"The rules that he wanted to impose on himself were based on a continuing effort to perfect them, the enthusiastic acceptance of great art produced by others, and the unconditional refusal of the market of the banal and the everyday."

[H. Tietze]

"Klimt was a simple person, stimulated only by decorative, bright, multi-colored subjects. He must have laughed often at hearing that the critics saw in his works profound philosophical problems to which he had certainly never given a thought."

[J. Engelhart, 1943]

## Praise from women

*Alma Mahler-Werfel is one of the most interesting and unusual female figures of this century. The daughter of a famous Viennese landscape painter, she was a childhood friend of Klimt. In 1902 she married the composer Gustav Mahler, whose music she influenced, and at his death became the lover of Kokoschka until 1915. She later married the architect Walter Gropius, whom she left to marry the novelist Franz Werfel.*

"Many years later he himself said that we had looked for each other all our lives without finding each other. For him, playing with feelings was a hobby... He had no one around him except women who were worthless, and for this reason he sought me out, because he felt that I could help him. Gustav Klimt came to me as the first great love of my life, but at the time I was still an unaware child, profoundly immersed in music and far out of the world."

[A. Mahler-Werfel]

"He varies the theme of women in all his relations with creation, with nature. Now cruelly voluptuous, now slightly sensual, he paints women charged with an enigmatic charm... To obtain the ideal figure, however, he dissolves the female body into dazzling, decorative lines. Every casual, characteristic trait of an individual falls away, and there remains only the pure typical moment, the sublimated essence of the modern feminine type, as the artist has discerned it, in absolute purity of style."

[Berta Zuckerkandl, 1908]

## HIS LIFE IN BRIEF

**1862.** Klimt was born on July 14 in Baumgarten, near Vienna, the son of a gold engraver and an opera singer.

**1876.** Enrolled in the School of Applied Arts where he learned a vast range of expressive forms.

**1886.** Began the decorations of the halls of the Burgtheater, finished in 1888.

**1890.** Painted the portrait of the pianist Pembauer and began the decoration of the Kunsthistorisches Museum, which kept him busy until 1891.

**1895.** Went through his symbolist phase, painting works like *Love and Music*.

**1897.** Founded the Vienna Secession and the magazine Ver Sacrum. At the same time prepared studies for the decoration of the Great Hall at the University of Vienna.

**1899.** Painted panels for Dumba. Went through a phase of philosophical allegorism. Various exhibitions held of Secession works.

**1900.** Klimt exhibited the unfinished canvas of *Philosophy*, made for the University, causing a scandal; at the the Universal Exposition in Paris it was awarded the prize as best foreign work

**1901.** Painted *Judith I*.

**1902.** For the Secession exhibition painted the *Beethoven Frieze*, where he defines art as consolation. Met Rodin in Paris. Entered his golden phase.

**1903.** Went to Ravenna twice to see the Byzantine mosaics.

**1905.** Withdrew from the Secession. Concentrated on the cartoons for Palais Stoclet in Brussels.

**1907.** Fully immersed in his golden phase. Met Schiele. Painted *The Kiss*.

**1911.** Won the first prize ex-aequo at the International Exposition of Art in Rome. Traveled to London, Madrid, and Brussels, where the mosaic was installed in Palais Stoclet.

**1912.** His crisis over, he moved toward a flowery style reminiscent of Japanese art.

**1916.** With Schiele and Kokoschka took part in the exhibition of the Berlin Secession.

**1917.** Nominated honorary member of the Vienna Academy of Fine Arts.

**1918.** Returning from a trip to Romania on January 6, he suffered a stroke and died in the hospital on February 6.

**1945.** The fire set by occupying Soviet troops destroyed the castle of Immerdorf, where numerous works by Klimt were stored. Destroyed were 16 of his most famous paintings and various drawings.

## WHERE TO SEE KLIMT

*The following is a catalogue of the principal works by Klimt conserved in public collections.*
*The list of works follows the alphabetical order of the cities in which they are found. The data contain the following elements: title, dating, technique and support, size in centimeters, location.*

BRUSSELS (BELGIUM)
**Mosaic Frieze,**
1909-11; Palais Stoclet.

DRESDEN (GERMANY)
**The Beech Forest I,**
1902; oil on canvas, 100x100; Gemäldegalerie Neue Meister.

INNSBRUCK (AUSTRIA)
**Portrait of the pianist Joseph Pembauer**
1890; oil on canvas, 69x55; Tiroler Landesmuseum Ferdinandeum.

LINZ (AUSTRIA)
**Maria Munk,**
1917-18; oil on canvas, 180x90; Neue Galerie der Stadt Linz.

**Portrait of a Lady,**
1916-17; oil on canvas, 67x56; Neue Galerie der Stadt Linz, Wolfgang Gurlitt Museum.

**Cows in the Stable,**
1900-01; oil on canvas, 75x75; Neue Galerie der Stadt Linz, Wolfgang Gurlitt Museum.

LONDON (GREAT BRITAIN)
**Portrait of Hermine Gallia,**
1904; oil on canvas, 170.5x96.5; National Gallery.

MUNICH (GERMANY)
**Music I,**
1895; oil on canvas, 37x44.5; Bayerische Staatsgemäldesammlungen (Neue Pinakothek).

**Margaret Stonborough-Wittgenstein,**
1905; oil on canvas, 180x90; Bayerische Staatsgemäldesammlungen (Neue Pinakothek).

NEW YORK (UNITED STATES)
**Expectation (Hope II),**
1907-08; oil on canvas, 110.5x110.5; Museum of Modern Art.

**The Park,**
1909-10; oil on canvas, 110.5x110.5; Museum of Modern Art.

**Mäda Primavesi,**
c. 1912; oil on canvas, 150x110; Metropolitan Museum of Art.

**Lady with a Fur Collar,**
1897-98; oil on cardboard, 36x19.5; Saint Etienne Gallery.

OTTAWA (CANADA)
**Hope I,**
1903; oil on canvas, 181x67; National Gallery of Canada.

PITTSBURGH (UNITED STATES)
**Flowery Field,**
c. 1909; oil on canvas, 110.5x100.5; Carnegie Institute.

PRAGUE (CZECH REPUBLIC)
**The Virgin,**
1912-13; oil on canvas, 190x200; Národni Galerie.

ROME (ITALY)
**The Three Ages of Woman,**
1905; oil on canvas, 180x180; Galleria Nazionale dell'Arte Moderna.

VENICE (ITALY)
**Judith II,**
1909; oil on canvas, 178x46; Galleria d'Arte Moderna Ca' Pesaro.

VIENNA (AUSTRIA)
**The Embrace,**
1905-09, mixed media on cardboard, 194x121; Österreichische Galerie.

**Adam and Eve,**
1917-19; oil on canvas, 173x60; Österreichische Galerie.

**The Girlfriends,**
1903-07; black chalk, 45.2x31.2; Historisches Museum der Stadt Wien.

**Love,**
1895; oil on canvas, 60x44; Historisches Museum.

**The Kiss,**
1907-08; oil on canvas, 180x180; Österreichische Galerie.

**Field of Poppies,**
1907; oil on canvas, 110x110; Österreichische Galerie.

**Danae,**
c. 1907-08; oil on canvas, 77x 83; Private Collection.

**Pregnant Woman,**
1907-08; pencil and red and blue crayon,
55.9x37.1; Historisches Museum der Stadt
Wien.

**Fable,**
1883, oil on canvas, 84.5x117;
Historisches Museum der Stadt Wien.

**Beethoven Frieze,**
1902; mixed media, 220x2400;
Österreichische Galerie.

**Judith I,**
1901; oil on canvas, 84x42;
Österreichische Galerie.

**Garden with Sunflowers,**
1905-06; oil on canvas, 110 x110;
Österreichische Galerie.

**Idyll,**
1884; oil on canvas, 49.5x73.5;
Historisches Museum der Stadt Wien.

**Interior of the old
Burgtheater, Vienna,**
1888; oil on canvas, 82x92; Historisches
Museum der Stadt Wien.

**Nuda Veritas,**
1899; black chalk, pencil, pen and ink,
41.3x10.4; Museum des 20. Jahrhunderts.

**Pallas Athene,**
1898; oil on canvas, 75x75; Historisches
Museum der Stadt Wien.

**Adele Bloch-Bauer,**
1907; oil on canvas, 138x138;
Österreichische Galerie.

**Emilie Flöge,**
1902; oil on canvas, 178x80;
Historisches Museum der Stadt Wien.

**Fritza Riedler,**
1906; oil on canvas, 153x133;
Österreichische Galerie.

**Sonja Knips,**
1898; oil on canvas, 145x145;
Österreichische Galerie.

**Schloss Kammer on the Attersee III,**
1910; oil on canvas, 110x110;
Österreichische Galerie.

WASHINGTON (UNITED STATES)
**The Cradle,**
1917-18; oil on canvas, 110x110;
National Gallery of Art.

48

## BIBLIOGRAPHY

For further knowledge of the periods which characterized Klimt's artistic development, the general catalogues of his work should be consulted.

**1901**  H. Bahr, *Rede über Klimt*, Vienna

**1903**  H. Bahr, *Gegen Klimt*, Vienna

**1918**  E. Schiele, *Nachruf auf Klimt,* in *Der Anbruch*, Vienna

**1919**  H. Tietze, *Gustav Klimts Persönlichkeit. Nach Mitteilungen seiner Freunde,* in *Die Bildenden Künste*, Vienna

**1943**  C. Moll, *Erinnungen an Gustav Klimt,* in *Neues Wiener Tagblatt*

**1968**  R. Bossaglia, *Il Liberty in Italia*, Milan

**1969**  C.M. Nebehay, *Gustav Klimt. Dokumentation*, Vienna

**1970**  W. Hofmann, *Gustav Klimt und die Wiener Jahrhundertwende*, Salzburg

**1975**  A. Comini, *Gustav Klimt*, London

Vergo, *Art in Vienna. Klimt, Kokoschka, Schiele and their Contemporaries*, Oxford

**1976**  M. Christian Nebehay, *Gustav Klimt. Sein Leben nach zeitgenössischen Berichten und Quellen*, Munich

**1978**  J. Dobai, *L'opera completa di Klimt*, Milan

**1980-84**  A. Strobl, *Gustav Klimt. Die Zeichnungen*, 3 vols., Salzburg

**1981**  C. E. Schorske, *Vienna fin de siècle*, Milan (New York 1961)

O. Breicha, *Gustav Klimt*, Milan (Salzburg 1978)

**1982**  J. Apferthaler, *Byzantinismus bei Klimt und der Sezession*, Vienna

**1983**  J. Dobai, *Gustav Klimt. Die Landschaften*, Salzburg

*Gustav Klimt*, exh. cat., Venice

S. Sabarsky, *Gustav Klimt, Oskar Kokoschka e Egon Schiele*, Milan

**1985**  E. Di Stefano, *Il complesso di Salomè. La donna, l'amore e la morte nella pittura di Klimt*, Palermo

*Wien 1870-1930. Traum und Wirchlichkeit*, exh. cat., Vienna.

**1986**  J. Pierre Bouillon, *Klimt: Beethoven*, Geneva

J. Clair, *Vienne 1890-1938. L'apocalypse joyeuse*, Paris

**1987**  S. Sabarsky, *Gustav Klimt*, exh. cat., Brussels

W. G. Fischer, *G. Klimt und Emilie Flöge*, Vienna

**1988**  E. Di Stefano, *Gustav Klimt*, Art Dossier no. 29, Florence

*Emilie Flöge und Gustav Klimt. Doppelporträt in Ideallandschaft,* exh. cat., Vienna

**1990**  G. Friedl, *Gustav Klimt*, Milan

Flormann, *Klimt and the Precedent of Ancient Greece,* in *Art Bulletin*

**1992**  F. Whitford, *Klimt*, Milan (London 1900)

**1995**  S. Sabarsky, *Gustav Klimt*, Florence

*Gustav Klimt*, exh. cat., Florence

**1996**  C. Dean, *Gustav Klimt*, London

# ONE HUNDRED PAINTINGS:

## every one a masterpiece

### ——— Also available: ———

*Raphael, Dali, Manet, Rubens,
Leonardo, Rembrandt, Van Gogh,
Kandinsky, Renoir, Chagall*

**Vermeer**
*The Astronomer*

**Titian**
*Sacred and Profane Love*

**Klimt**
*Judith I*

**Matisse**
*La Danse*

**Munch**
*The Scream*

**Watteau**
*The Embarkment for Cythera*

**Botticelli**
*Allegory of Spring*

**Cézanne**
*Mont Sainte Victoire*

**Pontormo**
*The Deposition*

**Toulouse-Lautrec**
*At the Moulin Rouge*

### ——— Coming next in the series: ———

*Magritte, Modigliani, Schiele,
Poussin, Fussli, Bocklin, Degas,
Bosch, Arcimboldi, Redon*